Margaret Danyers College, Cheadle Hulme ✓ KT-387-068

The National Gallery LONDON

Introduced by MICHAEL WILSON

Assistant Keeper at the Gallery

Charles Letts and Company Limited London, Edinburgh, München and New York

Margaret Danyers College Catalogue: 06391 © 1977 Scala Istituto Fotografico Editoriale / Philip Wilson Publishers Ltd

First published in 1978 by Charles Letts and Company Limited, Diary House, Borough Road, London SEI IDW

Produced by Scala Istituto Fotografico Editoriale and Philip Wilson Publishers Limited

Designed by Paul Sharp

Printed in Italy by Cooperativa Lavoratori Officine Grafiche Firenze

ISBN 0 85097 257 4

Front cover: Portrait of a Man by Titian

Back cover: St Jerome in his Study by Antonello da Messina

The publishers would like to thank the National Gallery for supplying the colour transparencies, and Angelo Hornak for doing additional photography including the front cover.

Contents

- 4 Main Dates in the History of the Gallery
- 5 Introduction
- 9 Early Italian Schools
- 27 Early Northern Schools
- 43 Sixteenth-century Italy
- 59 Seventeenth-century Holland and Flanders
- 77 Seventeenth-century Italy, France and Spain
- 93 The Eighteenth Century
- 111 1800 onwards
- 127 Index
- 128 Plan of the Gallery

The Gallery is open from 10 am to 6 pm from Monday to Saturday, and from 2 pm to 6 pm on Sundays. Admission free.

All dimensions are given in centimetres.

Main Dates in the History of the Gallery

- 1824 foundation of the National Gallery, based on the collection of John Julius Angerstein and displayed in his house at 100 Pall Mall
- 1828 Sir George Beaumont Gift
- 1831 Reverend Holwell Carr Bequest
- 1834 collection moved to 105 Pall Mall
- 1838 new building opened in Trafalgar Square, designed by Sir William Wilkins
- 1846 public outcry against the Gallery administration, particularly its cleaning policy
- 1847 Vernon Gift
- 1853 Government Select Committee set up to examine the Gallery's constitution
- 1854 purchase of Krüger Collection
- 1855 Sir Charles Eastlake, first Director of the Gallery
- 1856 Turner Bequest
- 1863 presentation by Queen Victoria, at the wish of Prince Albert, of German paintings from his own collection
- 1866 Sir William Boxall succeeds as second Director
- 1871 purchase of seventy-seven paintings from the Peel Collection
- 1874 Sir Frederick Burton, third Director
- 1876 Wynn Ellis Bequest
 - new wing opened, designed by Sir James Barry (rooms 32-40)
- the central rooms opened, designed by Sir John Taylor (rooms 13, 29, 31, 39)
- 1894 Sir Edward Poynter, fourth Director
- 1897 Tate Gallery first opened, as an annexe to the Gallery
- 1903 foundation of the National Art-Collections Fund
- 1906 Sir Charles Holroyd, fifth Director
- 1910 Salting Bequest
- 1911 five west rooms opened (rooms 5, 10, 11, 12, 14)
- 1916 Layard Bequest
 - Sir Charles Holmes, sixth Director
- 1917 Lane Bequest
- 1923 Samuel Courtauld Fund
- 1924 Mond Bequest
- 1929 Sir Augustus Daniel, seventh Director
- 1934 Sir Kenneth Clark, eighth Director
- 1939– pictures evacuated to a quarry in Wales, musical recitals held in Gallery 1945 building
- 1945 Sir Philip Hendy, ninth Director
- 1955 Tate becomes an independent gallery
- 1968 Sir Martin Davies, tenth Director
- 1972 Alexander Gift
- 1973 Michael Levey, eleventh Director
- 1975 northern extension opened (rooms 19–27)

Introduction

Viewed from Trafalgar Square, the National Gallery with its dome, turrets and portico presents an aspect which is both severe and dignified. The Gallery had been established for fourteen years when, on April 9th 1838, it first opened in this newly-completed building. With its neo-Palladian grandeur, the facade, which remains virtually unchanged, gives some idea of the respect and seriousness with which the concept of a national collection was then regarded.

This had not always been the case. At the end of the eighteenth century when a national gallery was first being seriously considered, the government showed little interest. Some, like John Constable, were actually opposed to the idea. In 1823, by which date national galleries had already been established in Vienna, Paris, Amsterdam, Madrid and Berlin, the government failed to respond to Sir George Beaumont's offer to give his famous collection to the nation as soon as proper accommodation could be provided. However, in 1824, when it was discovered that the collection of John Julius Angerstein, a Russian-born financier recently deceased, was on offer to the Prince of Orange for \pounds 70,000, the government was finally spurred into action. Probably influenced by Sir George Beaumont's promise, and a similar offer by the Reverend Holwell Carr, the House of Commons voted \pounds 60,000 for the purchase, preservation and exhibition of Angerstein pictures. Thirty-eight were bought, among them fine works by Claude, Rubens and Rembrandt, together with the lease of Angerstein's house.

It was there, at 100 Pall Mall, in premises never intended for public display, that the growing collection remained for ten years. The Angerstein pictures were joined by those of Beaumont and Holwell Carr while others were contributed by the Treasury. A purpose-built structure was urgently needed and in 1831 designs submitted by William Wilkins for a new gallery were approved.

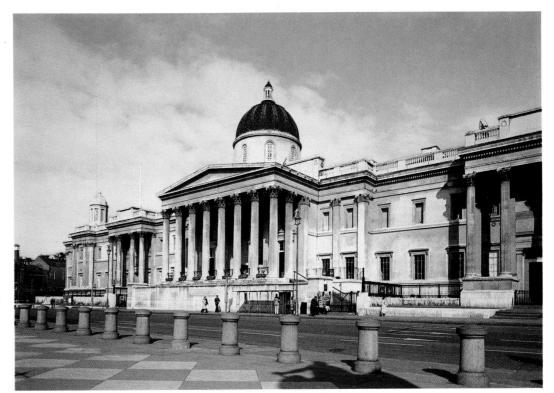

The main facade of the Gallery, designed by William Wilkins in 1834

Two years later work began on the site made vacant by the demolition of the King's mews on the north side of Trafalgar Square. However, early in 1834 it was discovered that Angerstein's house was in danger of collapse and the Gallery had to be removed to even more cramped quarters at 105 Pall Mall. There it was obliged to remain until Wilkins' building was ready.

In fact, when it was ready, the new gallery offered little more than an imposing facade. It may have improved the Gallery's prestige, but it was insufficient to accommodate a rapidly expanding collection. The site was unusually long and narrow. Consequently Wilkins' building comprised only one range of top-lit exhibition rooms with living quarters for the Keeper and offices beneath. Furthermore, until 1869 the section to the east of the dome was occupied by the Royal Academy.

Although the problems of lack of space, poor ventilation, dirt and noise continued to trouble the Trustees a crisis arose after the move to Trafalgar Square that was to have far greater consequences. Late in 1846 when a group of newly-cleaned pictures was exhibited, a storm of protest was levelled against the administration of the Collection and its policy of cleaning. It was claimed that such pictures as Rubens' '*Peace and War*' (p 72) and Titian's *Bacchus and Ariadne* (p 54) had been destroyed. They are with us today still in good condition, but in the mid-nineteenth century the public was accustomed to seeing pictures obscured by layers of dirt and discoloured varnish, the 'tone' of an old master. When the outcry was renewed in 1853, a Select Committee was set up by the government to examine the situation and as a result of its Report, the Gallery's constitution was revised.

A Keeper had been appointed in 1824 and later a 'committee of six gentlemen', including Sir George Beaumont and the painter Sir Thomas Lawrence, had been nominated to supervise the Collection, but no regular meetings were held and recommendations for the purchase of pictures were made to the Treasury very much according to the whim of individuals. In 1855, as a result of the inquiry of 1853, the first Director, Sir Charles Lock Eastlake, was appointed and an annual purchase grant was allocated. The responsibility for the purchase of pictures now rested with him alone, and while preference had previously been given to pictures by acknowledged masters of the sixteenth and seventeenth centuries, it was now resolved to build the Collection on historical principles and to include works by the precursors of these celebrated artists, the primitives of the fourteenth and fifteenth centuries.

Thus, during the second half of the century a systematic policy led to the acquisition of many of the Gallery's greatest treasures. A number of considerable gifts and bequests also swelled the Collection. The Vernon Gift of 1847 and the Turner bequest of 1856 contributed many modern British works, most of which, until the opening of Sir James Barry's new wing in 1876, were housed elsewhere. The purchase of seventy-seven pictures in 1871 from the Peel Collection and the Wynn Ellis bequest of 1876 suddenly gave the Gallery an extensive representation of Dutch painting but once again necessitated an expansion to the building. Barry's rooms in the east of the building were therefore followed in 1887 by a central spine of rooms and a new vestibule designed by Sir John Taylor. The five rooms to the west that balance Barry's wing were finally completed in 1911, after the buildings adjacent to the Gallery had been deemed a fire hazard and demolished.

Meanwhile, all but a small selection of the British pictures had left Trafalgar Square for the new national gallery at Millbank, the Tate, opened in 1897, where they remain today. Space was thereby gained for new foreign Room 32 in 1886, a contemporary painting by Guiseppe Gabrielli (now only known from this early photograph)

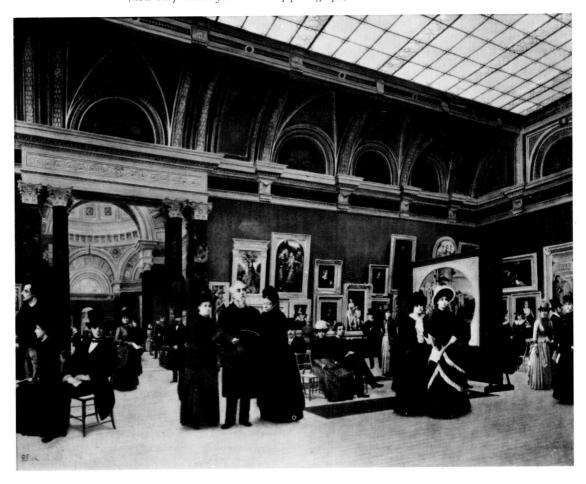

acquisitions and with the Salting and Lane bequests of 1910 and 1917 came the first considerable group of modern French paintings.

With the retirement of the third Director, Sir Frederick Burton, in 1894 there came another significant change for the Gallery. A revision of the constitution placed the authority for the purchase of pictures once again with the Trustees, and while it was hoped that unwise or erratic purchases would thereby be avoided, an era was thus terminated during which men of exceptional ability had been able to exercise their flair and talent unhindered, in securing top-rate pictures.

However, by the beginning of the twentieth century the circumstances in which Eastlake had operated, had greatly changed. The Gallery now had formidable competitors in Germany and America, and if acquisitions this century have often been less spectacular than formerly, they have also been more difficult. Yet when circumstances and funds permit, the Gallery continues to buy works of the highest quality, particularly in those areas previously neglected. Among the Gallery's recent purchases are pictures not only by Titian and Rembrandt, but also by such artists as 'Le Douanier' Rousseau, Klimt, Moreau, and Odilon Redon who were not previously represented in the Collection and whose work is very rare in this country.

These examples also indicate a significant change in attitude. Today an admiration for Raphael or Rubens need not preclude an appreciation of earlier and later painters, who may have worked outside the better-known traditions. As the Gallery moves away from a doctrinaire view of the history of art, so an attempt is now made to give all pictures the space and environment they need if each is to be seen in its own right and not merely as illustrating a stage in history.

The opening of the Northern Extension in 1975 has greatly increased the exhibition space, as well as providing such facilities as a cinema and a special exhibition area. These rooms incorporate modern lighting techniques that ensure not only that a picture may be seen to best advantage, but also that harmful ultra-violet light is excluded. Likewise air-conditioning controls temperature and humidity so as not to endanger old and fragile works, particularly those on wood. The Gallery has its own Scientific Department to investigate the deterioration of pictures in order that preventive measures can be introduced wherever possible and its own Conservation Department to clean and restore the pictures, not only curing the damage of time but also protecting them against further deterioration.

An imaginative display reduces the fatigue caused by a huge and monotonously hung collection. Exhibitions, audio-visual programmes, booklets, and lectures help in a variety of ways to introduce pictures to those who may find them unfamiliar or alien. Over the last few years the Gallery has devised more activities of this kind, not simply to give information but also to help people to get pleasure from the pictures it displays. The series of small 'Painting in Focus' exhibitions attempts to show familiar works in a new way. A single picture in the Collection is taken out of its normal gallery context, and hung in a different room with related material around it. Events are designed especially for children and the Gallery now has a colour workshop where they can learn about the techniques of painting in different media and experiment themselves. Today, more than ever before, the Gallery is making a positive effort to encourage both adults and children to look at pictures, and to make their visit as exciting as possible.

Early Italian Schools

The first early Italian works to be acquired by the National Gallery were Lorenzo Monaco's two groups of saints presented, not purchased, in 1848, twenty-four years after the founding of the Gallery. Now the altarpiece can be seen complete with its centre panel showing *The Coronation of the Virgin* (p 12) which was subsequently purchased by the Gallery in 1902.

For the first thirty years of the Gallery's existence until its reconstitution in 1855, the Keeper and Trustees had pursued a conservative and narrow policy of acquisition, inherited from the great private collectors of the eighteenth century. The pictures in the Angerstein, Beaumont and Holwell Carr collections which formed the nucleus of the new Gallery were for the most part by the accepted masters of the sixteenth and seventeenth centuries, and in the early years of the Gallery's history it was predominantly Italian paintings from this period that were acquired, works by artists such as Correggio, Titian, Annibale Carracci, and Guido Reni. Sir Robert Peel, a Trustee from 1827 until his death in 1850, regarded early Italian pictures merely as curiosities and opposed their purchase, attitudes which reflected the general feeling.

When, in 1846, the scandal broke over the Gallery's cleaning of its pictures, criticism was also directed against the purchasing policy of the Trustees, in particular against their predilection for the artists of the Bolognese School, such as Guido Reni. His *Susanna and the Elders* purchased in 1845 was described by Ruskin as 'devoid alike of art and decency'. Ruskin pursued his point in a letter to *The Times* in January 1847 in which he attacked 'the cumbering of our walls with pictures that have no single virtue, no colour, no drawing, no character, no history, no thought' and the failure to acquire any works by such artists as Perugino, Fra Angelico, Fra Bartolommeo and Verrocchio, artists who he thought interpreted nature with greater sincerity and purity of sentiment.

Consequently when the Inquiry of 1853 was set up to investigate the affairs of the Gallery, it did not fail to report upon the purchasing policy. The Treasury Minute of 1855 which abolished the old Gallery constitution also advised with respect to purchases that 'preference should be given to good specimens of the Italian Schools, including those of the earliest masters'. The new Director, Sir Charles Lock Eastlake, whose own tastes accorded with this new policy, began at once to put it into effect. It is largely due to Eastlake's initiative and energy that the Gallery has such a magnificent collection of fifteenth and sixteenth century Italian paintings. He had already served as Keeper. Now as Director he was able to exercise fully his powers of discrimination, and throughout the course of his directorship, he untertook regular tours of Italy to acquire suitable paintings for the Collection. It was in Italy that he was taken ill and died in the winter of 1865.

From his first visit in 1855 he returned with, among other fine things, a Botticelli, a Bellini and Mantegna's Virgin and Child (p 18). The following year he purchased the triptych by Perugino (p 26) and the marvellous St Sebastian altarpiece by the brothers Pollaiuolo (p 17). Towards the end of 1857 he purchased in Italy twenty-two works from the Lombardi Baldi collection, including The Battle of San Romano (p 15) one of three paintings executed by Uccello around 1450 for the Medici Palace in Florence. The next year saw the purchase of works by Cossa, Cima, Crivelli, and a fine late painting by Giovanni Bellini, The Madonna of the Meadow (p 23), and in 1861 the prize acquisition was The Baptism of Christ (p 20) by Piero della Francesca, an artist then barely recognised, purchased at the Uzielli sale for only $\pounds 241$. Eastlake's love of early Italian painting was inherited by his successors, Sir William Boxall and Sir Frederick Burton, and the prodigious stream of pictures acquired during the second half of the nineteenth century changed the whole balance of the Collection.

Among them were early fourteenth century works by the first great painter of the Sienese School, Duccio. The Annunciation (p 11) is one of three panels in the Gallery from the Maestà altarpiece which was executed for Siena Cathedral between 1308/11. The majority of the early Italian works in the Collection are religious in subject and were commissioned for churches. However, in the fifteenth century there was a dramatic move away from the conventions of Sienese painting towards a more naturalistic and monumental approach. The Madonna (p 14) in the panel by Masaccio, an artist working in Florence at the beginning of the century, is no longer flat and stylised: the pattern of light and shade gives an illusion of depth. Later still, in the St Sebastian altarpiece (p 17) by the brothers Pollaiollo, the traditional gold background has disappeared and the figures are shown in a variety of contrasting poses. The study of anatomy and perspective enabled painting to become more realistic and dramatic. The revival of interest in the art of antiquity led to an enthusiasm for profile portraits (p 17) in imitation of Roman coins and medals, and for subjects drawn from classical mythology, for example Botticelli's Venus and Mars (p 25) and the strange scene showing a satyr lamenting a dead nymph by Piero di Cosimo (p 26).

However, these early Italian works were still not regarded as masterpieces in their own right. In the Report of 1853 the Select Committee had drawn the following analogy: 'What Chaucer and Spenser are to Shakespeare and Milton, Giotto and Masaccio are to the great masterpieces of the Florentine School.' There was little doubt for Eastlake that the peak of western painting had been reached in Italy at the beginning of the sixteenth century. The early Italian pictures he collected were of importance in that they illustrated the early stages in the development of painting, and the art of the late sixteenth and the seventeenth century demonstrated the decline.

Today these pictures can be seen as independent achievements, not necessarily inferior to the art of the High Renaissance. In its display the Gallery attempts to provide suitable surroundings which will allow such pictures to stand alone as unique creations rather than historical specimens. Specially designed niches have recently been constructed for many of the early altarpieces, not to simulate their original situation, but to show them within a sympathetic architectural environment and enhance their visual effect.

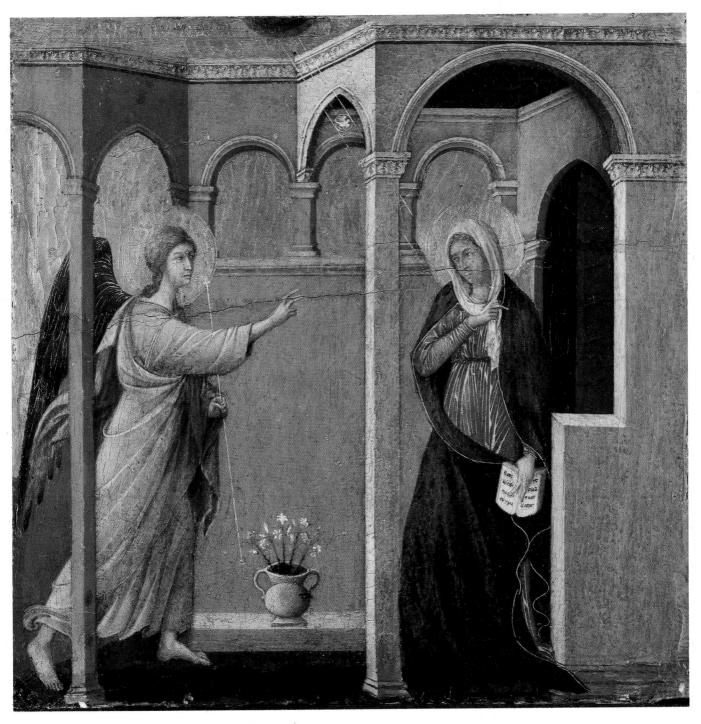

Duccio di Buoninsegna born and died Siena, active 1278 - died 1319*The Annunciation* (predella panel from an altarpiece) c 1308/11wood 43.2×43.8 Inscribed in Latin on the book held by the Virgin, from Isaiah, vii, 14: 'Behold, a virgin shall conceive, and bear a son and shall call his name . . .' Purchased 1883

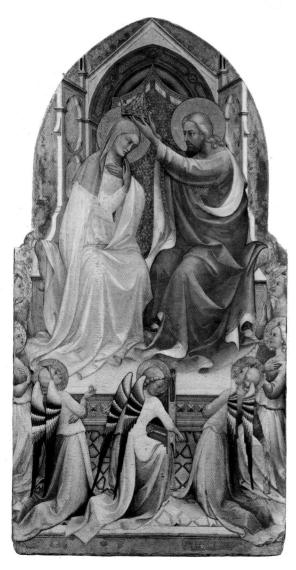

Style of Andrea de Cione called **Orcagna** active Florence c 1343, died 1368/69 *Noli me tangere* wood 55.2 × 37.8 Presented 1924

Duccio di Buoninsegna born and died Siena, active 1278 – died 1319 *The Virgin and Child* (centre panel of a triptych) probably before 1308 wood 42.5 × 34.5 Purchased 1857

Piero di Giovanni called Don **Lorenzo** Monaco born Siena before 1372, died Florence 1422/24*The Coronation of the Virgin* (centre portion of an altarpiece) c 1415 wood 217.2 × 115.6 Purchased 1902

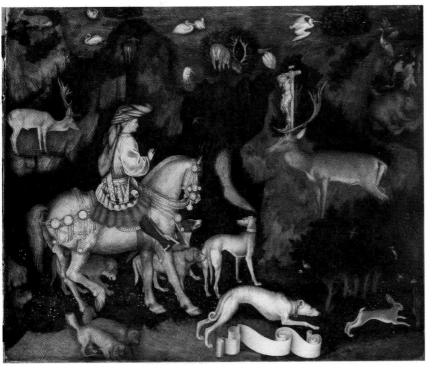

Antonio Pisano called **Pisanello** born Verona before 1395, died Naples 1455(?) *The Vision of St Eustace* wood 54.6 × 65.4 Purchased 1895

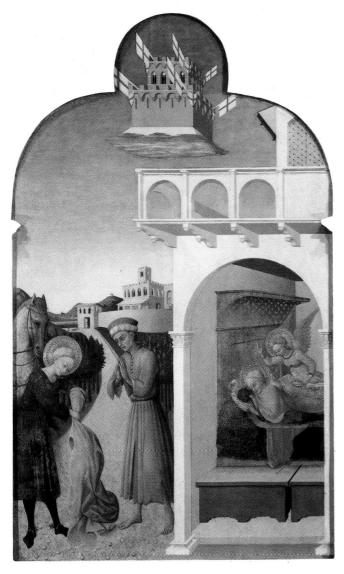

Giovanni di Paolo born and died Siena, c 1403-1482*The Baptism of Christ* (predella panel from an altarpiece) wood 30.8×44.5 Purchased 1944

Stefano di Giovanni called **Sassetta** born and died Siena, 1392(?)–1450 *The Whim of the Young St Francis to become a Soldier* (panel from an altarpiece) probably 1437/44 wood 87×52.4 Purchased 1934

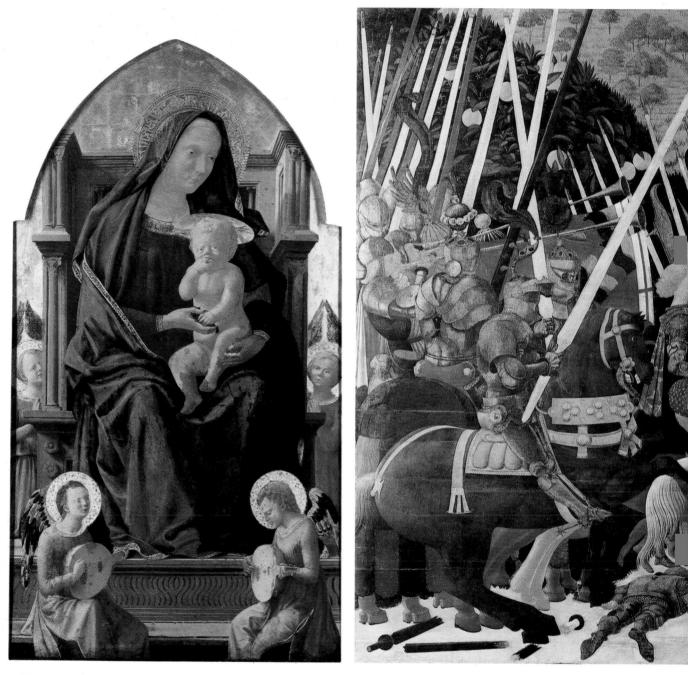

Tommaso di Giovanni, called **Masaccio** born San Giovanni Valdarno 1401, died Rome 1427/29 *The Virgin and Child* (centre panel of a polyptych) 1426 wood 135.3 \times 73 Purchased 1916

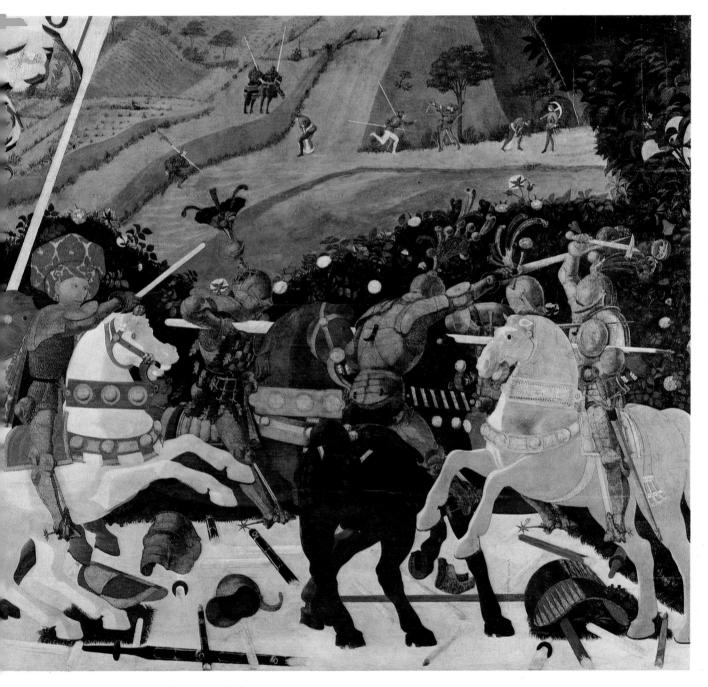

Paolo di Dono called **Uccello** born and died Florence, c 1397–1475 *The Battle of San Romano* (one of a series) c 1435/50 wood 181.6 \times 320 Purchased 1857

Guido di Pietro called Fra **Angelico** born Vicchio 1387, died Rome 1455 *Christ Glorified in the Court of Heaven* (centre panel of the predella from an altarpiece) c 1435 wood 31.8×73 Purchased 1860

> Ascribed to **Masolino** born Panicale c 1383, died after 1432 *St John the Baptist and St Jerome* (wing of a triptych painted on both faces) c 1428/31 wood 114.3 × 54.6 Purchased 1950

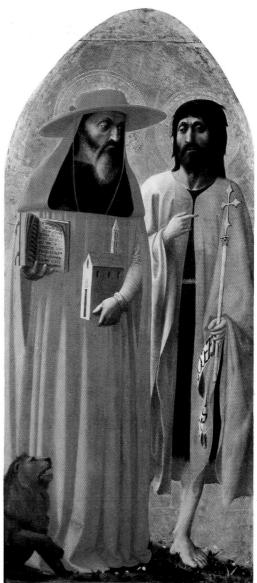

Fra Filippo Lippi

born Florence c 1406(?), died Spoleto 1469 The Annunciation (a pendant to 'Seven Saints') c 1448(?) wood 68.6×152.4 Presented 1861

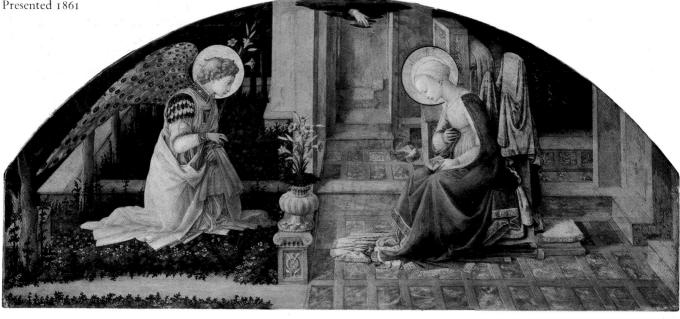

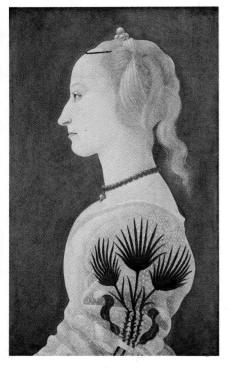

Alesso **Baldovinetti** born and died Florence, c 1426–1499 *Portrait of a Lady* c 1465 wood 62.9×40.6 Purchased 1866

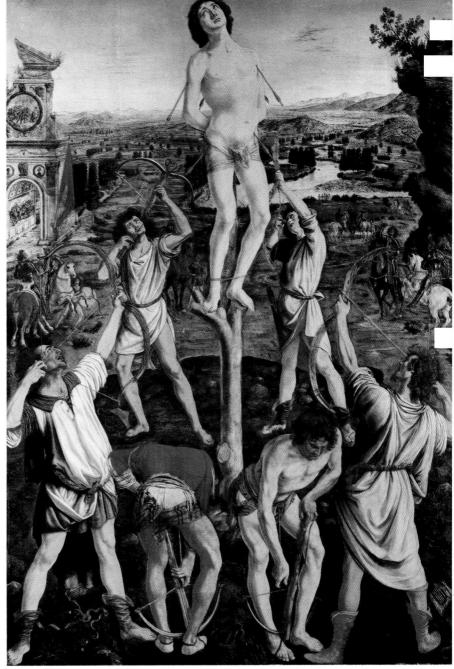

Ascribed to the brothers Antonio and Piero del **Pollaiuolo** both born and died Florence, c 1432–1498, c 1441–1496 *The Martyrdom of St Sebastian* (altarpiece) c 1475 wood 291.5 \times 202.6 Purchased 1857

Piero della Francesca born and died Borgo San Sepolero, 1410/20–1492 *The Nativity* a late work wood 124.4×122.6 Purchased 1874

Andrea **Mantegna** born Isola di Carturo c 1430/31, died Mantua 1506 *Samson and Delilah* a late work linen 47×36.8 Inscribed in Latin with a proverb: 'Woman is evil, a trifle worse than the devil' Purchased 1883

> Andrea **Mantegna** born Isola di Carturo c 1430/31, died Mantua 1506 The Virgin and Child with the Magdalen and St John the Baptist (altarpiece) c 1469(?) canvas 139.1×116.8 signed Purchased 1855

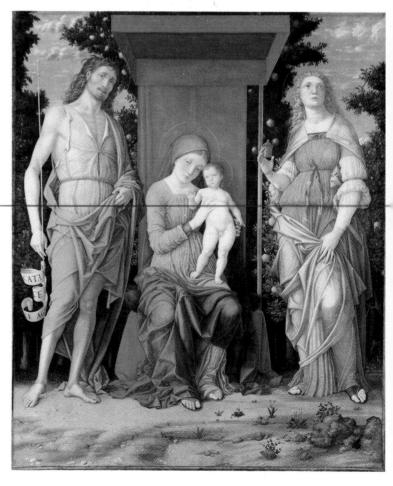

18

Carlo Giovanni **Crivelli** born Venice between 1435/40, died Ascoli Piceno 1493 *The Annunciation with St Emidius* (altarpiece) 1486 canvas, transferred from wood 207×146.7 signed and dated Presented 1864

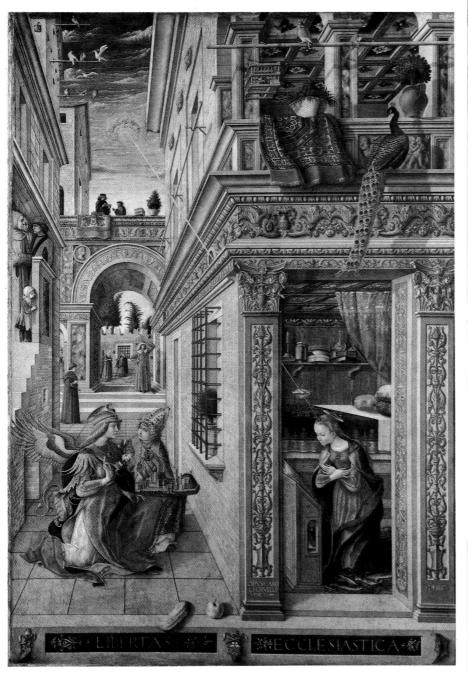

Lorenzo **Costa** born Ferrara 1459/60, died Mantua 1535 *A Concert* an early work wood 95.3 × 75.6 Bequeathed 1910

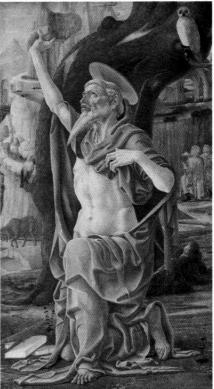

Cosimo **Tura** born and died Ferrara, c 1431–1495 St Jerome (fragment) wood 101×57.2 Purchased 1867

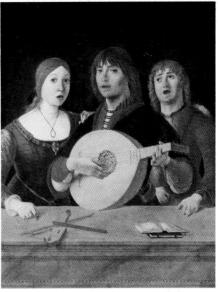

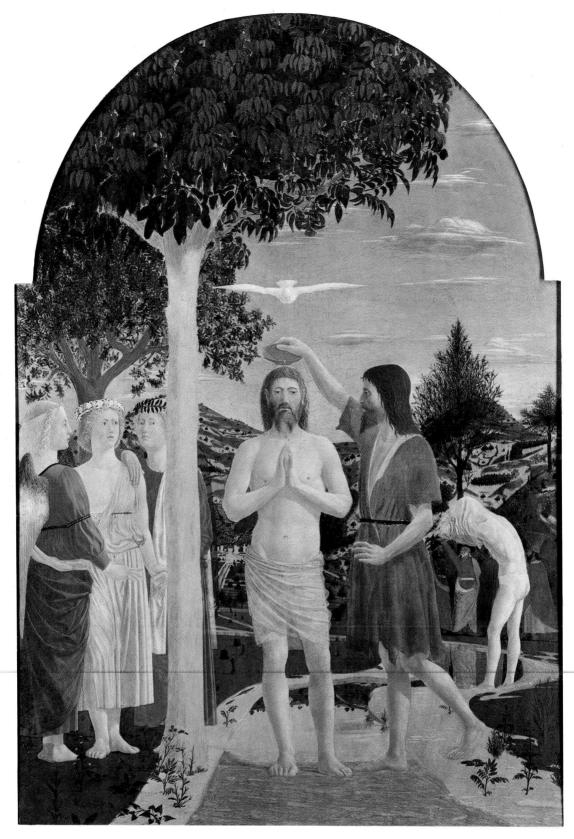

Piero della Francesca born and died Borgo San Sepolcro, 1410/20–1492 *The Baptism of Christ* (part of an altarpiece) an early work wood 167.6×116.2 Purchased 1861

Andrea **Mantegna** born Isola di Carturo c 1430/31, died Mantua 1506 *The Agony in the Garden* 1460s(?) wood 62.9 × 80 signed Purchased 1894

Francesco Raibolini called **Francia** born and died Bologna, c 1450–1517/18 *The Virgin and Child with Saints* (altarpiece) c 1511 canvas, transferred from wood 195 × 180.5 Purchased 1841

Antonello da Messina born and died Messina, c 1430–1479 *Portrait of a Man* c 1475 wood 35.6 × 25.4 Purchased 1883

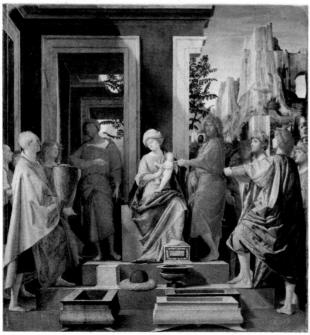

Bartolomeo Suardi called **Bramantino** born and died Milan, 1450/55–1530 *The Adoration of the Kings* probably 1490 wood 56.8 × 55 Bequeathed 1916

Antonello da Messina born and died Messina, c 1430–1479 St Jerome in his Study c 1456(?) wood 45.7 × 36.2 Purchased 1894

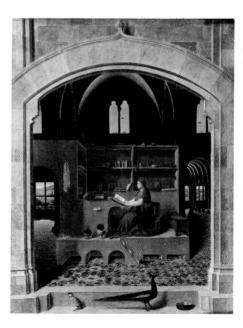

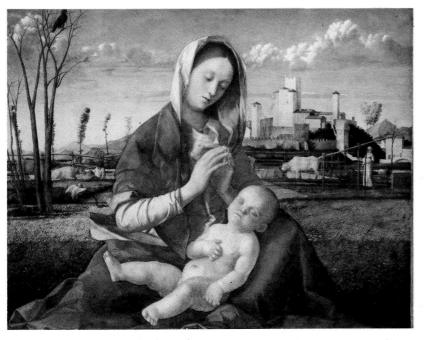

Giovanni **Bellini** born and died Venice, c 1430–1516 *The Madonna of the Meadow* a late work board, transferred from wood 67.3×86.4 Purchased 1858

Giovanni **Bellini**

born and died Venice, c 1430-1516The Agony in the Garden c 1465wood 81.3×127 Purchased 1863

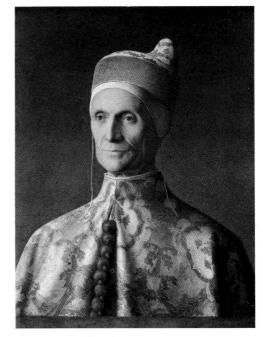

Giovanni **Bellini** born and died Venice, c 1430-1516*The Doge Leonardo Loredan* c 1501wood 61.6×45.1 signed Purchased 1844

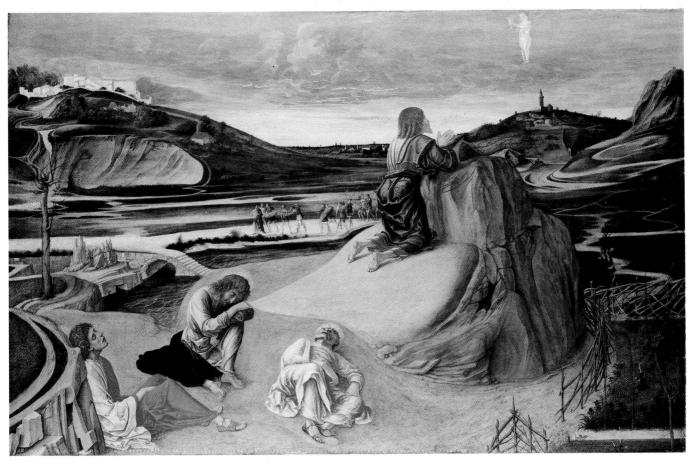

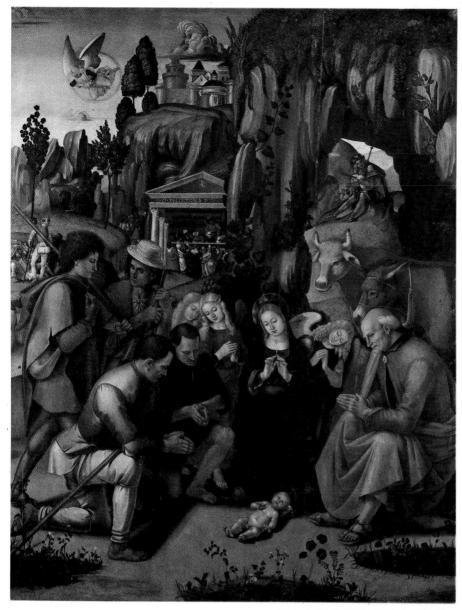

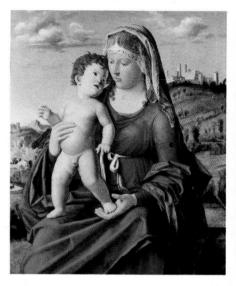

Giovanni Battista **Cima** da Conegliano born Conegliano 1459/60, died Venice 1517/18 *The Virgin and Child* wood 69.2 × 57.2 signed Purchased 1858

Luca **Signorelli** born and died Cortona, 1441(?)–1523 *The Adoration of the Shepherds* (altarpiece) probably 1496 wood 215.9×170.2 signed Purchased 1882

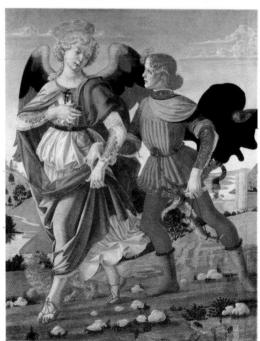

Follower of Andrea del Verrocchio born Florence c 1435, died Venice 1488 *Tobias and the Angel* early 1470s(?) wood 83.9×66 Purchased 1867

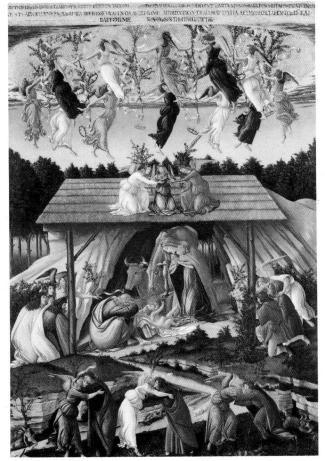

Alessandro di Mariano Filipepi called Sandro **Botticelli** born and died Florence, c 1445–1510 *The Mystic Nativity* c 1500

canvas 108.6×74.9

Inscription at the top is in Greek, the precise interpretation is obscure: 'I Sandro painted this picture at the end of the year 1500(?) in the troubles of Italy in the half time according to the 11th Chapter of St John in the second woe of the Apocalypse in the loosing of the devil for three and a half years then he will be chained in the 12th Chapter and we shall see clearly (?)... as in this picture'

Purchased 1878

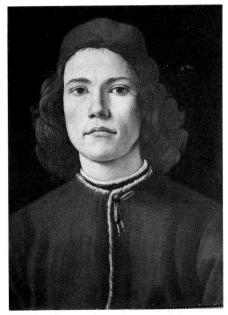

Alessandro di Mariano Filipepi called Sandro **Botticelli** born and died Florence, c 1445–1510 *Portrait of a Young Man* c 1482(?) wood 37.5 × 28.3 Purchased 1859

Alessandro di Mariano Filipepi called Sandro **Botticelli** born and died Florence, c 1445–1510 *Venus and Mars* 1480s(?) wood 69.2×173.4 Purchased 1874

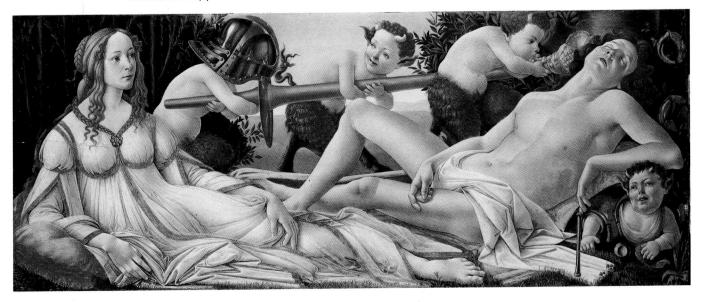

Filippino Lippi

born Prato 1457(?), died Florence 1504 The Adoration of the Kings an early work wood 57.5×85.7 Purchased 1882

> **Piero** di Cosimo born and died Florence, c 1462–1521 *A Mythological Subject* wood 65.4×184.2 Purchased 1862

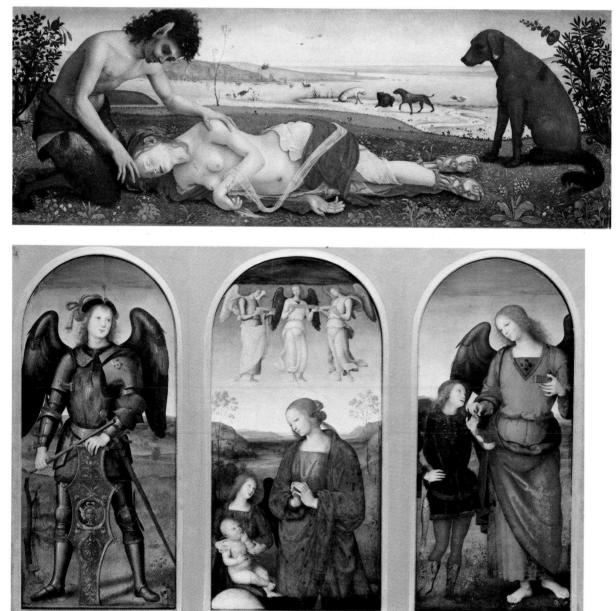

Pietro Vannucci called Perugino

born Città della Pieve c 1445/50, died Fontignano 1523 The Virgin and Child with St Raphael and St Michael (three panels of an altarpiece) begun c 1496 wood centre panel 127×64.1 side panels 126.4×57.8 signed Purchased 1856

Early Northern Schools

The collection of early Netherlandish and German pictures at the National Gallery is very much smaller than the early Italian collection, yet contains a large proportion of works of the highest quality, by Jan van Eyck, Rogier van der Weyden, Memlinc and Holbein to mention only the most familiar names. There are still however notable absences. Sixteenth-century Flanders is only represented by a few artists, Jan Gossaert for example (p 36), and the Gallery possesses hardly any post-Renaissance German works.

Fortunately, however, the revival of interest in 'primitive' painters in the middle of the nineteenth century extended beyond the Italian schools to the early masters of the north, and from the 1840's a slow stream of Netherlandish and German pictures began to trickle into the National Gallery. Yet they never received the earnest attention devoted to the Italian fifteenth century, and most of the pictures illustrated in this section were acquired this century. It is only comparatively recently that the concept of the Renaissance has been expanded to include the revolution in painting that occurred in Flanders in the fifteenth century and a little later in Germany, and perhaps only now are the works of van Eyck and van der Weyden granted a status equal to that of their contemporaries in the south. It is recognised today that the artists of the north did more than imitate the discoveries made in Italy, that in the development of realism and the formulation of oil-painting, they in fact anticipated the achievements of the Italian fifteenth century. Antonello da Messina and Giovanni Bellini, two seminal figures in the Italian Renaissance, both owed much to the Netherlandish painting they knew from examples brought to Italy.

The Renaissance in the north was less indebted to the classic art of Greece and Rome. In Bruges, and later in Brussels and Antwerp, economic expansion increased the demand for works of art and led to rapid developments in painting. There was a move away from the flat, linear conventions of Gothic art to a detailed modern realism, in which distinct human types are of central importance. Jan van Eyck built on the advances made by Robert Campin (p 30). His *Arnolfini Marriage* (p 32), one of the first early Netherlandish paintings to enter the Collection, illustrates his achievement in formulating a system which is naturalistic in its details and in its placing of figures and objects within a defined space. It is signed by the artist, who, unlike the anonymous medieval craftsman of the previous century, now dares, as it were, to proclaim his presence in his work. His *Man in a Turban* (p 31) may be a self-portrait. Here one can observe the new realism as its most accomplished, the folds of the turban are minutely observed, and in the finely painted features we find, virtually for the first time, the portrayal of a specific personality, neither schematized nor idealized.

The first German picture to enter the Collection was the portrait by Baldung (p 39) then attributed to Dürer. Purchased at Eastlake's insistence in 1854, just before the reconstitution of the Gallery, it is indicative of the new emphasis then being given to the purchase of earlier works. In the same year the Krüger collection, which consisted chiefly of early German pictures, was bought at Minden, and these works still represent a considerable part of the German collection at the National Gallery. Among them were six fragments of an altarpiece by the Master of Liesborn, including *The Annunciation* (p 38), and other works from his circle. The altarpiece had been installed in the Abbey Church at Liesborn in Westphalia by 1490 and remained there until the early nineteenth century. Less naturalistic in style than contemporary Netherlandish painting, for example the triptych by Memlinc (p 33), it shows the influence

27

of the important fifteenth-century Cologne School, particularly in the elegant poses of the figures and the decorative treatment of architecture and costume.

More German pictures, including examples from Cologne, entered the Gallery in 1863, presented by Queen Victoria at the wish of the Prince Consort. Prince Albert, a friend of Eastlake, was largely responsible for the growth of interest in 'primitive' painting, both Italian and Northern. Among his pictures which came to the Gallery in 1863 were the wing of an altarpiece by the Master of the St Bartholomew altarpiece showing St Peter and St Dorothy (p 38), a fine late work of the Cologne School, and a panel by the most famous master of Cologne, Staphan Lochner, which shows the Gothic style still flourishing in Germany at the middle of the fifteenth century.

A painting which shows German art at a more developed stage is the portrait attributed to Dürer, showing his father (p 40). This penetrating study of character (the authorship of which is still questioned) was presented to Charles I by the city of Nurenburg in 1636 and was purchased by the Gallery in 1904. The first Holbein to enter the Collection was the famous 'Ambassadors' (p 42) purchased in 1890. This painting had been in English possession since its execution, as had the Portrait of Christina of Denmark (p 42) which was saved from leaving the nation in 1909 when the National Art-Collections Fund succeeded in purchasing it for the Gallery. The portrait shows the young widow of the Duke of Milan, whom Henry VIII in 1538 was hoping to take as his fourth wife. From a study Holbein made that year in Brussels he produced this full-length portrait for the King, but in 1540 Henry married Anne of Cleves and the Duchess probably never saw Holbein's painting of her.

The National Art-Collections Fund has on many occasions since its foundation in 1903 helped to acquire works of exceptional quality and importance which would otherwise have almost certainly left the country. In 1929 it contributed to the purchase of one of the most valued objects in the Collection, *'The Wilton Diptych'* (p 29). This work, which had been in the collection of the Earls of Pembroke at Wilton House since the eighteenth century, shows Richard II, King of England from 1377 to 1399, being presented to the Virgin and Child by his patron saints. It is generally thought to be French in origin and may have been painted for the King to commemorate his marriage to Isabella of France in 1396. In its elaborate and decorative description of detail, and its rich gem-like colouring, *'The Wilton Diptych'* is representative of the International Gothic style that flourished throughout Europe in the early fifteenth century. Features of this style are seen not only in paintings of the northern artists, but also in the work of early Italian masters such as Pisanello and Uccello.

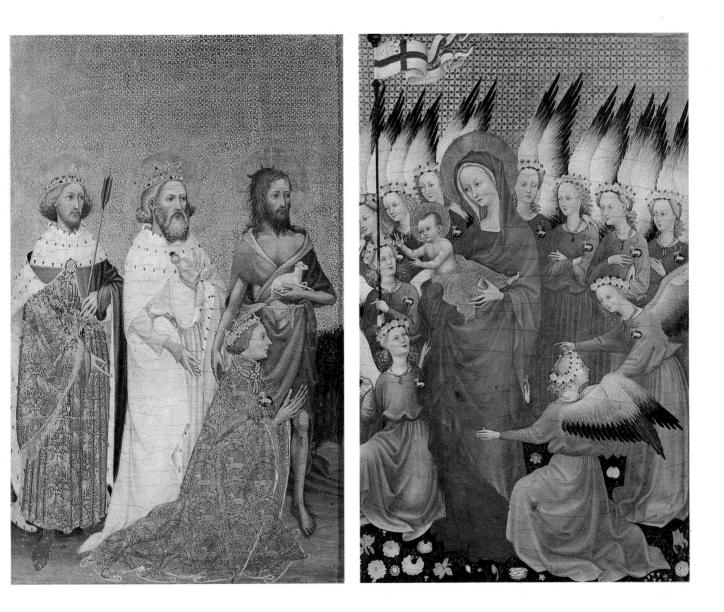

French School Richard II presented to the Vigin and Child by his patron saints 'The Wilton Diptych' c 1395 or later wood each panel 45.7×29.2 Purchased 1929

EARLY NETHERLANDISH

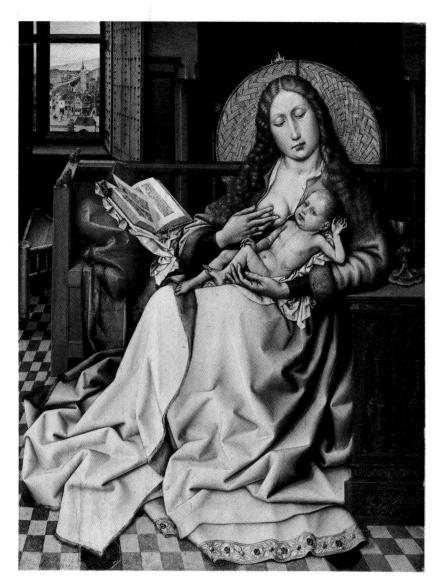

Robert Campin

born and died Tournai, 1378/79–1444 The Virgin and Child before a Firescreen before 1430 wood 63.5 × 49.5 Bequeathed 1910

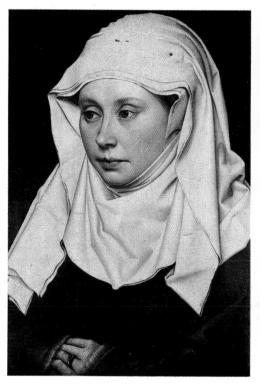

Ascribed to Robert **Campin** born and died Tournai, 1378/79–1444 *A Woman* an early work wood 40.7 × 27.9 Purchased 1860

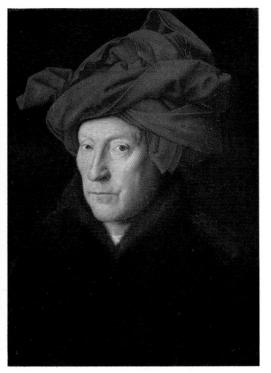

Jan van **Eyck** born Maaseyck c 1390, died Bruges 1441 *A Man in a Turban* 1433 wood 33.3 × 25.8 signed and dated Purchased 1851

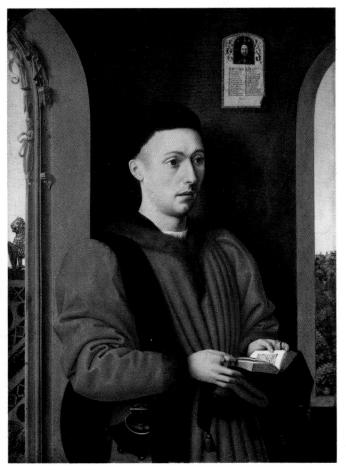

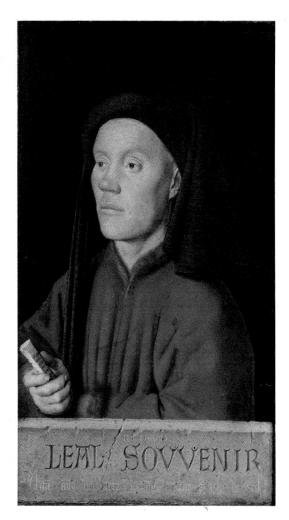

Jan van **Eyck** born Maaseyck c 1390, died Bruges 1441 *Portrait of a Young Man* 1432 wood 34.4×19 signed and dated Purchased 1857

Petrus **Christus** born Baerle, active 1442, died Bruges 1472/3 *Portrait of a Young Man* c 1450/60 wood 35.6×26.4 Bequeathed 1910

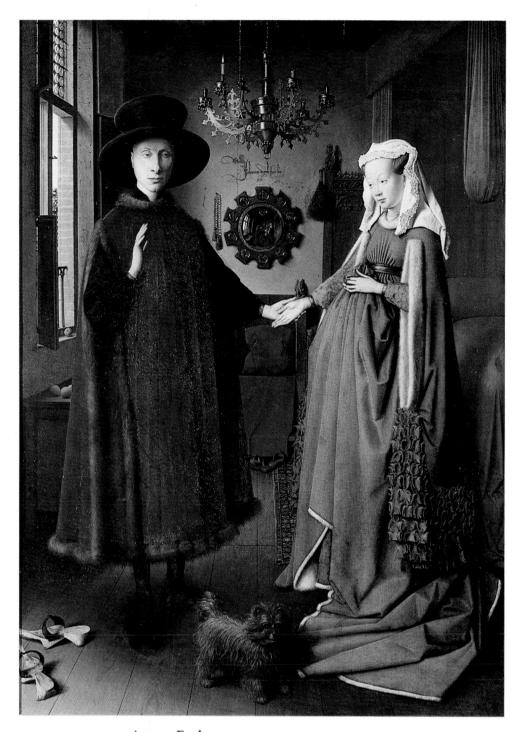

Jan van **Eyck** born Maaseyck c 1390, died Bruges 1441 *The Arnolfini Marriage* 1434 wood 81.8 × 59.7 signed and dated Purchased 1842

R.

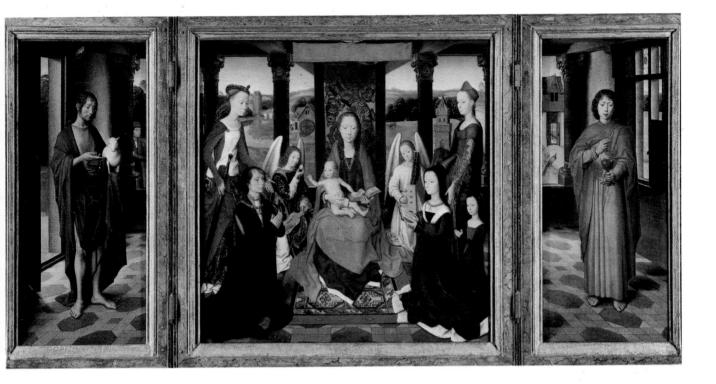

Hans Memlinc

born Mainz between 1425/40, died Bruges 1494 The Virgin and Child with Saints and Donors (triptych) c 1477 wood centre 70.8 \times 70.5, wings 71.1 \times 30.5 Purchased 1957

Rogier van der **Weyden** born Tournai c 1399, died Brussels 1464 *Pietà* wood 35.6×45.1 Purchased 1956

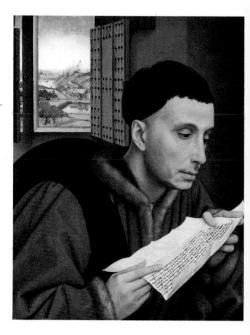

Rogier van der **Weyden** born Tournai c 1399, died Brussels 1464 *St Ivo* c 1450? wood 45.1 × 34.8 Purchased 1971

EARLY NETHERLANDISH

Gerard **David** born Oudewater c 1460, died Bruges 1523 *The Adoration of the Kings* (panel from an altarpiece) after 1515 wood 59.7 × 58.4 Bequeathed 1880

Hans **Memlinc** born Mainz between 1425/40, died Bruges 1494 A Young Man at Prayer c 1475 wood 38.7×25.4 Bequeathed 1910

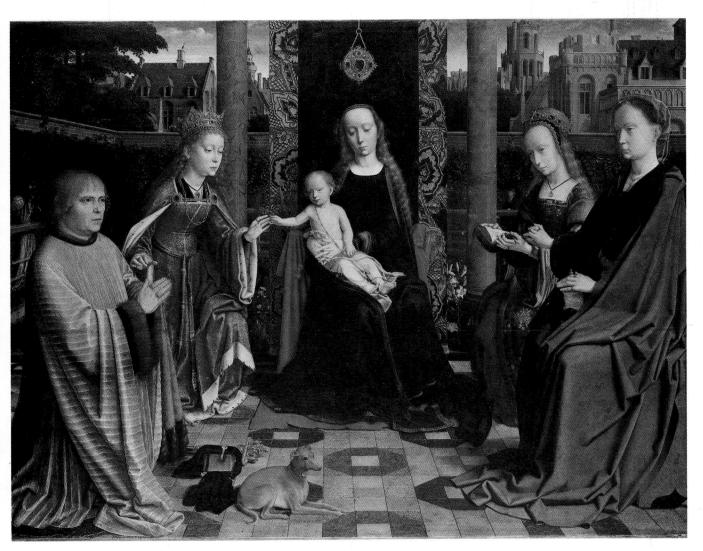

Gerard **David** born Oudewater c 1460, died Bruges 1523 Virgin and Child with Saints and Donor (panel from an altarpiece) c 1505/09wood 106×144.1 Bequeathed 1895

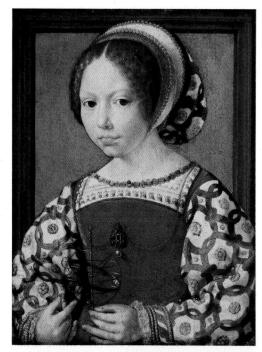

Jan **Gossaert** called **Mabuse** born Maubeuge c 1478, died Middleburg 1532 *A Little Girl* c 1520(?) wood 38.1 × 28.9 Purchased 1908

Ascribed to Joachim **Patenier** born Bouvignes c 1485, died Antwerp not later than 1524 *St Jerome in a Rocky Landscape* wood 36.2×34.3 Bequeathed 1936

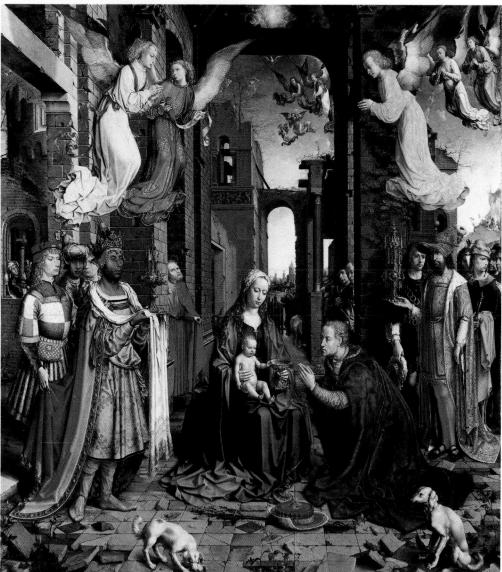

Jan **Gossaert** called **Mabuse** born Maubeuge c 1478, died Middleburg 1532 *The Adoration of the Kings* c 1506 wood 177.2 × 161.3 signed Purchased 1911

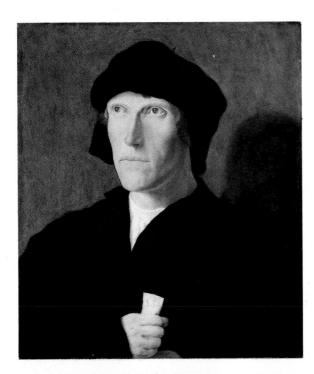

Lucas van Leyden born and died Leyden, c 1494–1533 *A Man aged thirty-eight* c 1521 wood 47.6×40.6 Inscribed on the paper in the sitter's hand: 38 Presented 1921

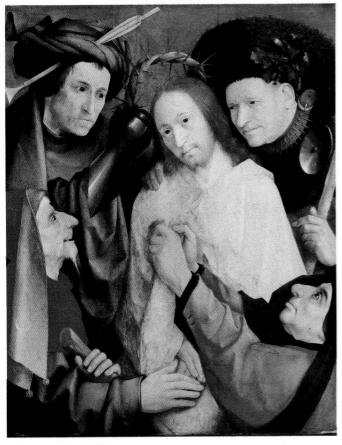

Hieronymus **Bosch** born and died Bois-le-Duc, 1450/60-1516*Christ mocked* probably an early work wood 73.5×59.1 Purchased 1934

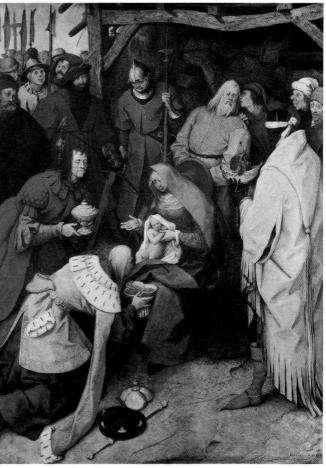

Pieter **Bruegel** the Elder born Campin c 1525, died Brussels 1569 *The Adoration of the Kings* 1564 wood 111.1×83.2 signed and dated Purchased 1920

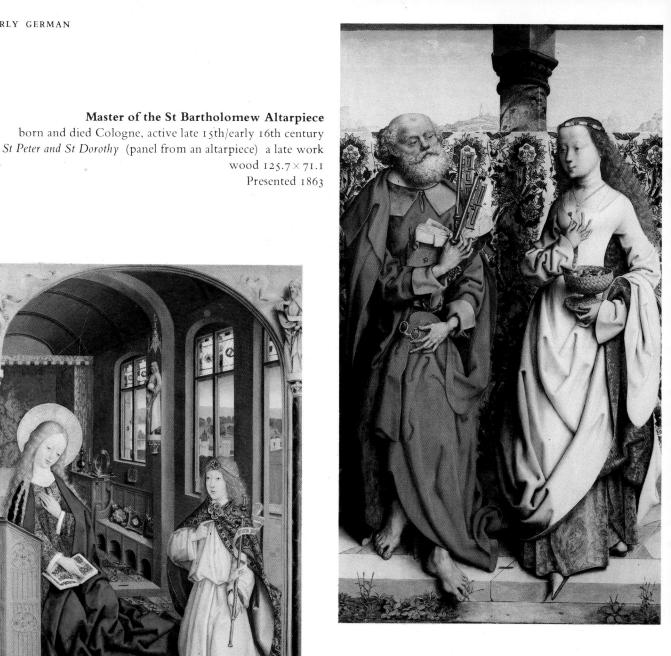

Master of Liesborn Westphalia, active second half of the 15th century The Annunciation (panel from an altarpiece) c 1480 wood 98.7×70.5 Purchased 1854

Stephan Lochner

born Meersburg 1405/15, died Cologne 1451 St Matthew, St Catherine and St John the Evangelist (wing of an altarpiece) a late work wood 68.6×58.1 Presented 1863

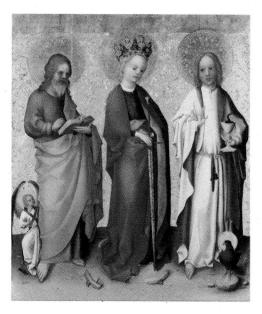

38

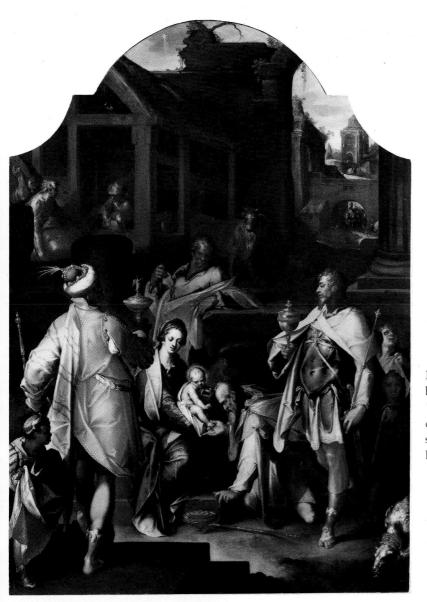

Bartholomeus **Spranger** born Antwerp 1546, died Prague 1611 *The Adoration of the Kings* c 1595 canvas 199. 8×143.7 signed Purchased 1970

Hans **Baldung** Grien born Gmünd 148.4/85, died Strasbourg 1545 *Portrait of a Man* 1514 wood 59.3 × 48.9 dated Purchased 1854

> Albrecht **Altdorfer** born and died Regensburg, c 1480–1538 *Landscape with a Footbridge* c 1518/20(?) parchment on wood 41.2×35.5 Purchased 1961

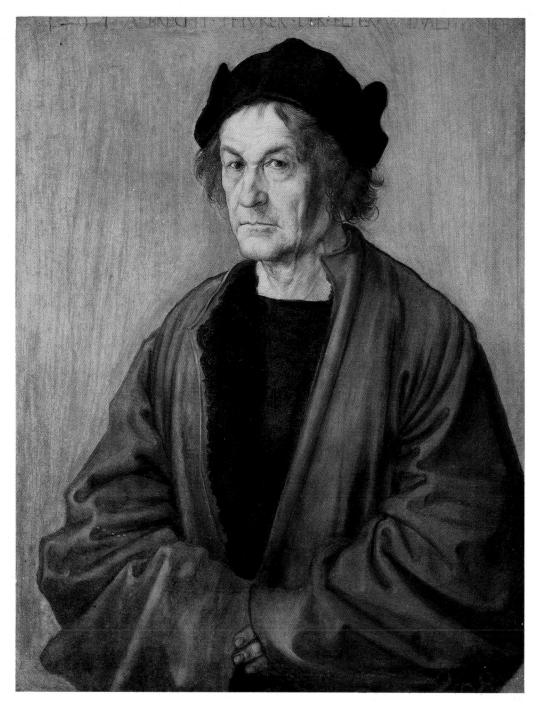

Ascribed to Albrecht **Dürer** born and died Nuremburg, 1471–1528 *The Painter's Father* 1497 wood 51×40.3 dated Purchased 1904

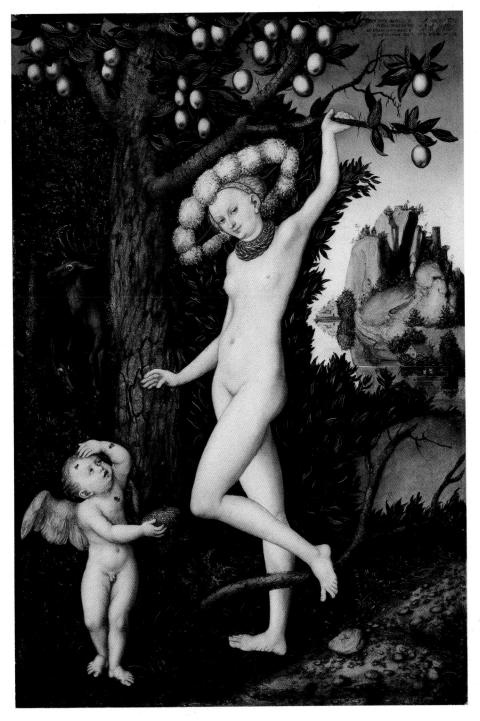

Lucas **Cranach** the Elder born Kronach 1472, died Weimer 1553 *Cupid complaining to Venus* after 1522(?) wood 81.3 × 54.6 signed Purchased 1963

41

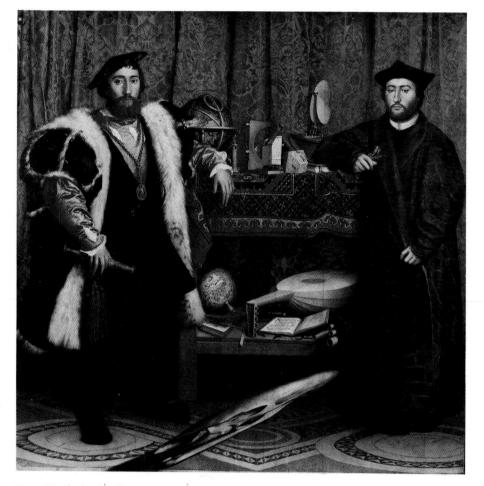

Hans **Holbein** the Younger born Augsburg 1497/98, died London 1543 Jean de Dinteville and Georges de Selve, 'The Ambassadors' 1533 wood 207×209.5 signed and dated Purchased 1890

> Hans **Holbein** the Younger born Augsburg 1497/98, died London 1543 *Christina of Denmark, Duchess of Milan* probably 1538 wood 179.1 × 82.6 Presented 1909

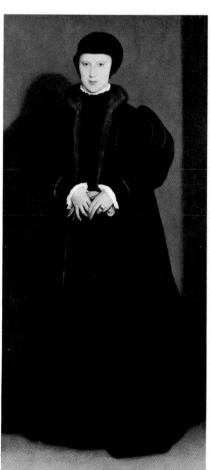

Sixteenth-century Italy

The National Gallery is rare and fortunate in that it possesses fine examples of virtually all the major Italian artists of the High Renaissance. In the very first years of its existence the Gallery acquired by purchase, gift and bequest a group of sixteenth-century Italian pictures which remains one of its chief glories. Catalogued number one in the Gallery's inventory is the enormous altarpiece of *The Raising of Lazarus* (p 51) by Sebastiano del Piombo, one of the Angerstein pictures bought in 1824. Michelangelo provided his protégé Sebastiano with studies for parts of this picture which was executed in 1517/19 in competition with Raphael's *Transfiguration* in the Vatican Museum. In 1825 The Treasury purchased the Gallery's first Correggio, *The Madonna of the Basket* (p 48) and in 1834 two more were added, an *Ecce Homo* and '*The School of Love*' (p 48). It seems that this picture was intended to represent spiritual love, in contrast to its pendant, the *Antiope* in the Louvre, which shows carnal love.

Titian's Bacchus and Ariadne (p 54), one of the three Bacchanals which he painted for Alfonso d'Este, Duke of Ferrara, was purchased in 1826. After recent cleaning it shows not only his mastery of movement, but also his dramatic use of vibrant colour. In the same year the British Institution presented a Veronese and Parmigianino's large altarpiece of *The Madonna and Child with St John the Baptist and St Jerome* (p 52) painted when the artist was only twenty years old. Among the pictures bequeathed by the Reverend Holwell Carr in 1831 were the *St George and the Dragon* by Tintoretto (p 58), a comparatively small work by the artist which shows his sophisticated use of design and light, Barocci's 'Madonna del Gatto' (p 57) and an early Titian, *The Holy Family*.

The keenness with which The Treasury and the Trustees seized at every opportunity to acquire such works and their frequency among the early bequests and gifts to the Gallery indicate how highly they were valued in the early nineteenth century. They had long been collected by the English and until late in the century it was never really questioned that during the High Renaissance painting had reached its point of perfection. Even when the seventeenth century fell from favour and earlier pictures became popular, the Gallery continued to spend large sums on important sixteenth-century Italian works. In 1857 Eastlake finalised the purchase of Veronese's great *Family of Darius before Alexander* (p 58) bought from the Pisani family at Venice for the then colossal sum of $\pounds 13,650$. Veronese lends dignity to his subject and emphasises Alexander's magnanimity towards the conquered Persians by arranging the many and varied figures into a composition which is harmoniously balanced.

Eastlake's successor, Boxall, succeeded in purchasing one of Michelangelo's very rare easel paintings, *The Entombment* (p 49) in 1868. According to one account, it had been discovered by its previous owner, the painter Robert Macpherson, as part of a street barrow in Rome. The first Leonardo to enter the Collection was *The Virgin of the Rocks* (p 46), purchased in 1880, an earlier variant of which is in the Louvre, and in 1884 a large altarpiece by Raphael, *The Ansidei Madonna* (p 47) was bought from the Duke of Marlborough for \pounds 70,000. Thus before the end of the century the Gallery became one of the very few collections to possess important works by Leonardo, Raphael, Michelangelo and Titian, traditionally considered the greatest artists of the period if not of the whole of western painting.

Recent acquisitions of paintings by these artists illustrate not only the comparative difficulty of obtaining such works nowadays, but also the extraordinary achievement of sixteenth-century Italy. In 1962 Leonardo's famous cartoon of *The Virgin and Child with St Anne and St John the Baptist* (p 45) which had belonged to the Royal Academy since the end of the eighteenth century, was purchased by the National Art-Collections Fund and presented to the Gallery. Dating from around 1500 it marks the attainment of a new aesthetic. The naturalistic detail of fifteenth-century painting here gives way to a more sophisticated and lyrical interpretation of form, where contours are blurred by diffused light, producing an effect which is both mysterious and moving.

A late Titian, *The Death of Actaeon* (p 55), as revolutionary in its handling of paint as the Leonardo Cartoon in its drawing, was purchased in 1972. A campaign was mounted to raise the enormous sum required to keep it in the country, and the price of $\pounds 1.76$ million was finally met by a combination of Gallery funds, a special government grant, and a large public subscription. In this painting the crisp form and bright colour of the earlier *Bacchus and Ariadne* give way to turbulent, moody paintwork and sombre tones. Diana, gigantic and inhuman in her role as avenger dominates the composition, while against a background of storm-wracked trees the hounds overwhelm the helpless Actaeon, already half-transformed into a stag. At this point, when every means, including the texture of the paint, is used to heighten the expression, painting seems to reach its maturity.

In 1970 one of the original Angerstein pictures was cleaned, revealing a hitherto unrecognised masterpiece. The *Pope Julius II* (p 45) had long been thought to be only one of many early copies of Raphael's portrait, but on cleaning, the stunning quality of the revealed paintwork, together with X-ray and other technical information, proved this to be not a copy but Raphael's original. It is another sixteenth-century work of seminal importance for European painting, providing a portrait format that was adopted subsequently by many major artists including Titian and Velazquez, and a more penetrating study of character than had yet been achieved in paint.

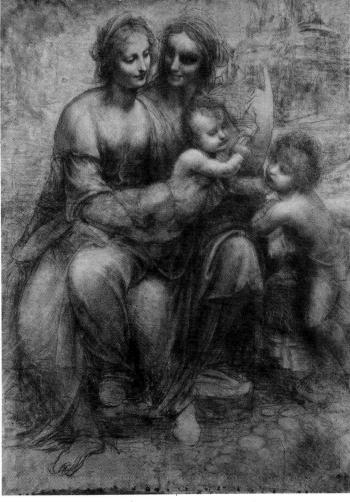

Raffaello Santi called **Raphael** born Urbino 1483, died Rome 1520 *Pope Julius II* c 1511/12 wood 108 × 80.7 Purchased 1824

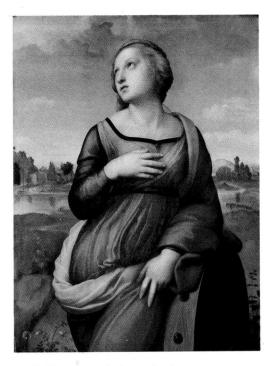

Raffaello Santi called **Raphael** born Urbino 1483, died Rome 1520 St Catherine of Alexandria c 1507 wood 71.5×55.7 Purchased 1839

Leonardo da Vinci born Vinci 1452, died Cloux 1519 *Virgin and Child with St Anne and St John the Baptist* (cartoon) c 1500 black chalk heightened with white on paper 141.5 \times 104.6 Presented 1962

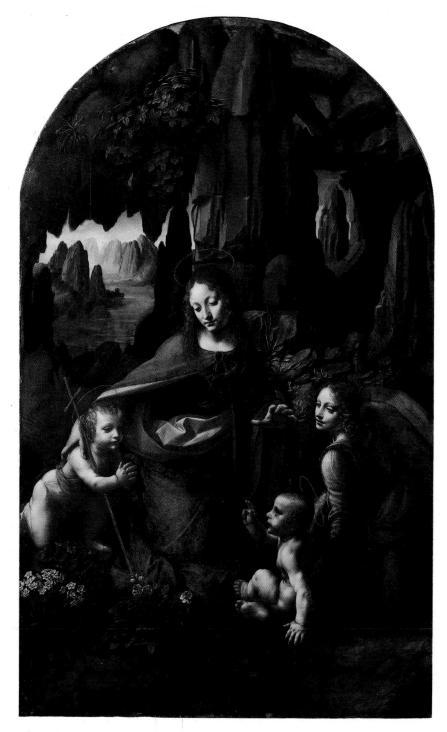

Leonardo da Vinci born Vinci 1452, died Cloux 1519 *The Virgin of the Rocks* (altarpiece) completed c 1506 wood 189.5 × 120 Purchased 1880

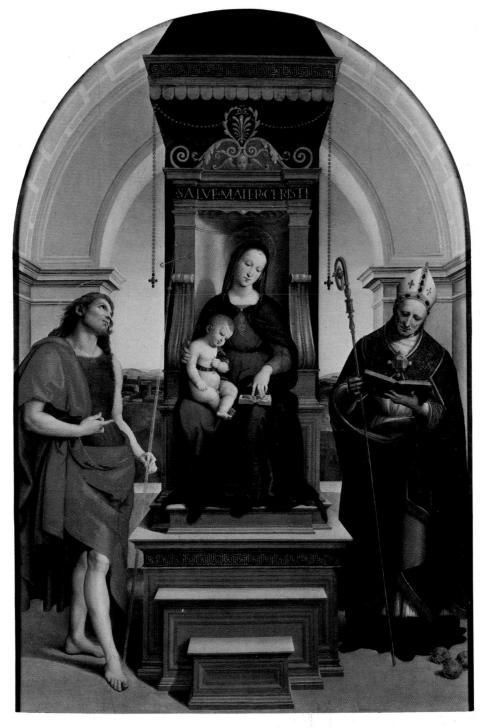

Raffaello Santi called **Raphael** born Urbino 1483, died Rome 1520 *The Ansidei Madonna* (altarpiece) 1505 wood 209.6 × 148.6 dated Purchased 1885

47

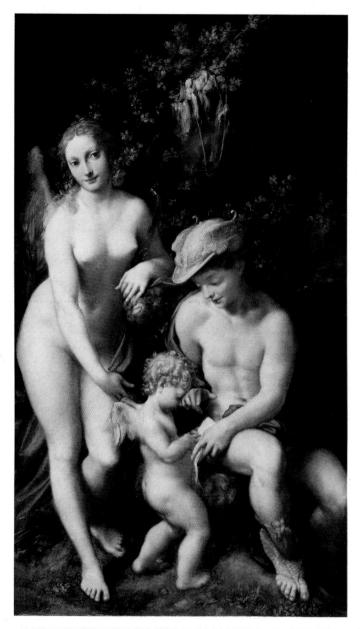

Antonio Allegri da **Correggio** born and died Correggio, c 1489/94–1534 *The Madonna of the Basket* c 1524(?) wood 33.7 × 25.1 Purchased 1825

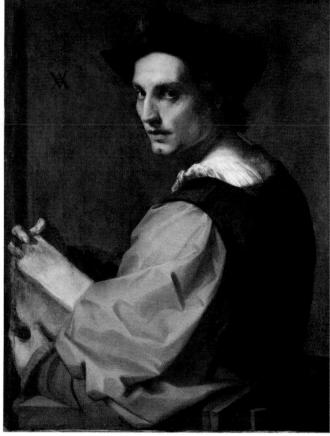

Antonio Allegri da **Correggio** born and died Correggio, c 1489/94–1534 *Mercury instructing Cupid before Venus, 'The School of Love'* an early work canvas 155.6 × 91.4 Purchased 1834

> Andrea d'Agnolo called del **Sarto** born and died Florence, 1486–1530 *Portrait of a Young Man* c 1517 canvas 72.4×57.2 signed with the artist's monogram Purchased 1862

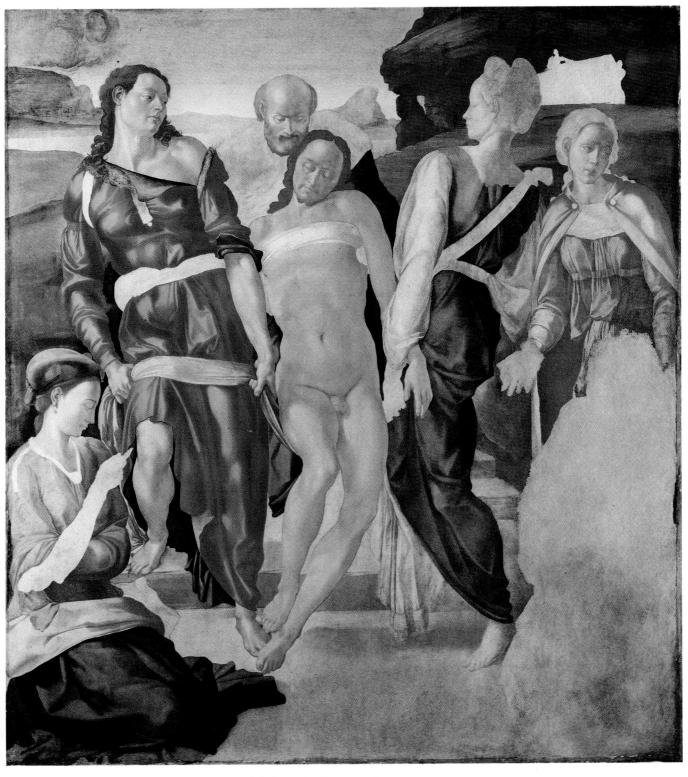

Michelangelo Buonarroti born Caprese 1475, died Rome 1564 *The Entombment* (unfinished) probably not earlier than 1505 wood 161.7×149.9 Purchased 1868

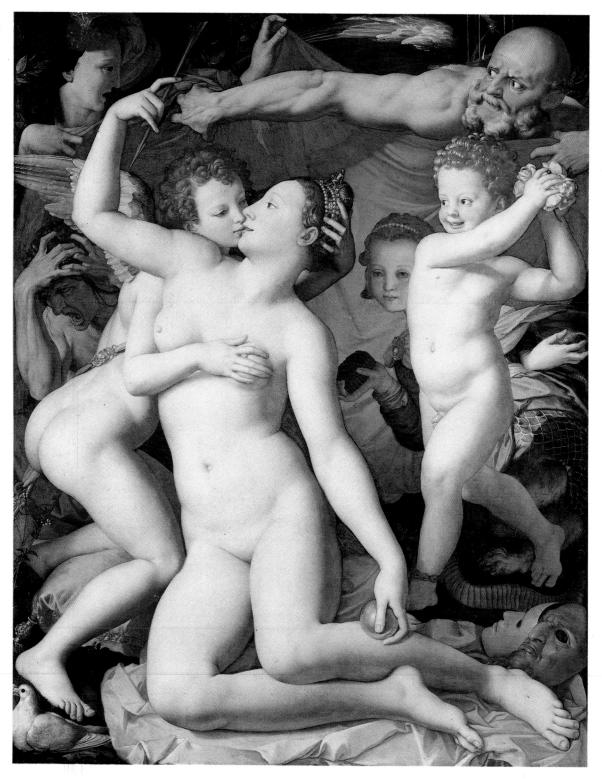

Bronzino

born and died Florence, 1503-1572An Allegory probably 1540s or 1550s wood 146.1×116.2 Purchased 1860

Sebastiano Luciani called **Sebastiano** del Piombo born Venice c 1485, died Rome 1547 *The Raising of Lazarus* 1517/19 board, transferred from wood 381 × 289.6 signed Purchased 1824

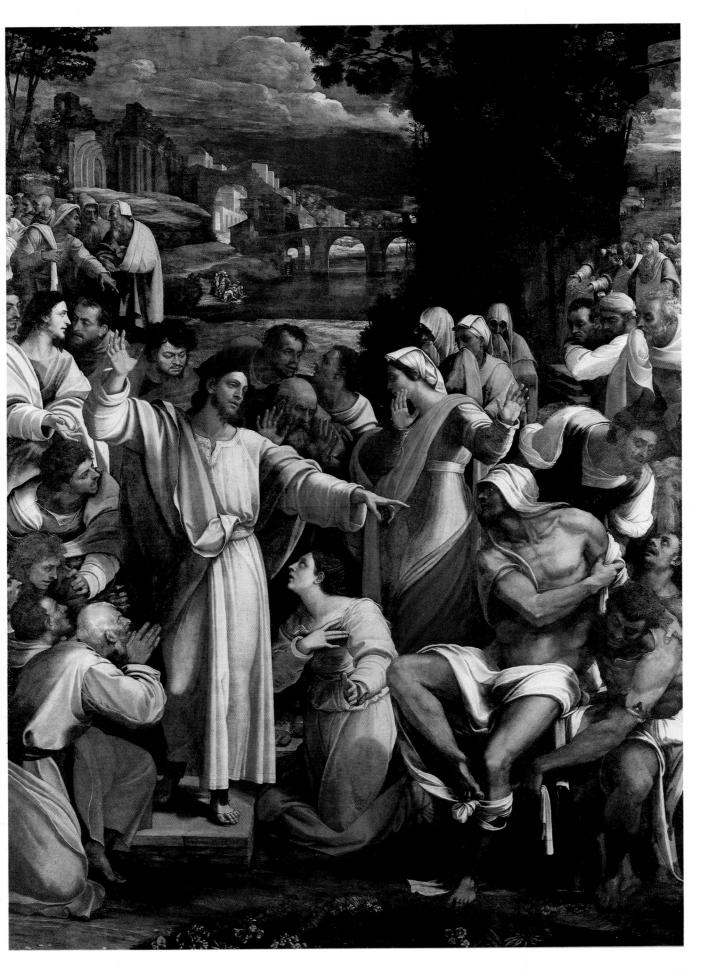

Girolamo Francesco Maria Mazzola called **Parmigianino** born and died Parma, 1503–1540 *Madonna and Child with St John the Baptist and St Jerome* (altarpiece) 1527 wood 342.9 × 148.6 Presented 1826

Girolamo Francesco Maria Mazzola called **Parmigianino** born and died Parma, 1503–1540 *The Mystic Marriage of St Catherine* probably 1527/31 wood 74.2 × 57.2 Purchased 1974

Jacopo Carucci called **Pontormo** born Pontormo 1494, died Florence 1557 *Joseph in Egypt* (one of a series) c 1515 wood 96.5 × 109.5 Purchased 1882

Ascribed to **Niccolo** dell 'Abate born Modena c 1509/12, died Fontainebleau 1571 *The Story of Aristaeus* after 1552 canvas 189.2 × 237.5 Presented 1941

Giorgio da Castelfranco called **Giorgione** born Castelfranco 1477/78, died Venice 1510 *Sunset landscape with Saints, 'Il Tramonto'* 1504(?) canvas 73.3 × 91.4 Purchased 1961

Giorgio da Castelfranco called **Giorgione** born Castelfranco 1477/78, died Venice 1510 *The Adoration of the Magi* 1506/07(?) wood 29.8 × 81.3 Purchased 1884

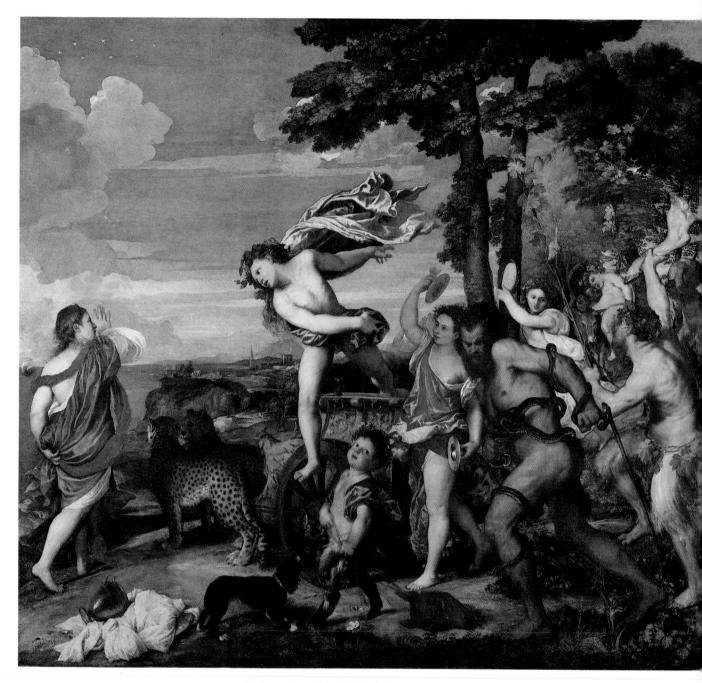

Tiziano Vecellio called **Titian** born Pieve di Cadore c 1480, died Venice 1576 *Bacchus and Ariadne* 1523 canvas 175.2×190.5 signed Purchased 1826

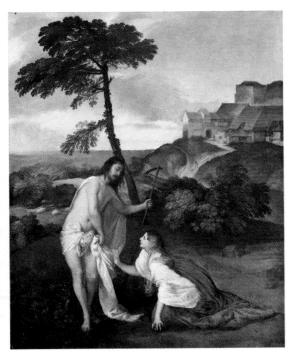

Tiziano Vecellio called **Titian** born Pieve di Cadore c 1480, died Venice 1576 *Noli me tangere* an early work canvas 108.6 × 90.8 Bequeathed, 1856

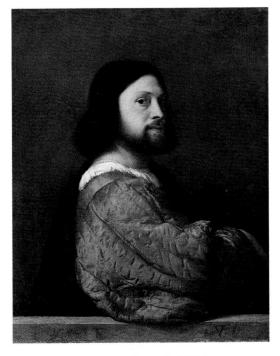

Tiziano Vecellio called **Titian** born Pieve di Cadore c 1480, died Venice 1576 *Portrait of a Man* c 1515(?) canvas 81.2 × 66.3 Purchased 1904

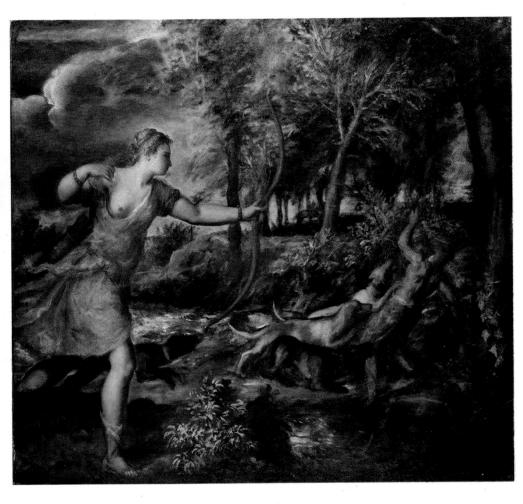

Tiziano Vecellio called **Titian** born Pieve di Cadore c 1480, died Venice 1576 *The Death of Actaeon* probably c 1559 canvas 178.4 × 198.1 Purchased 1972

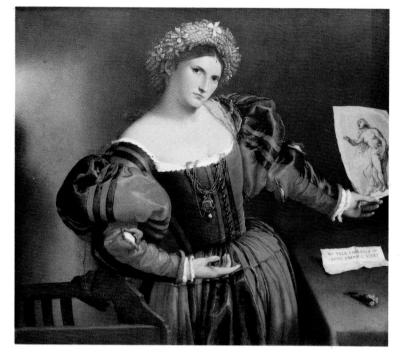

Lorenzo **Lotto** born Venice c 1480, died Loreta after 1556 *A Lady as Lucretia* c 1530 canvas 95.9×110.5 Inscribed in Latin: 'After Lucretia's example let no violated woman live.' Purchased 1927

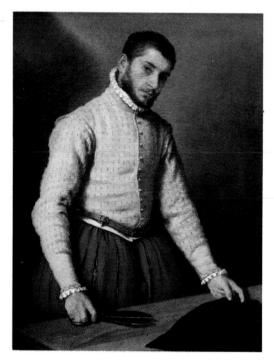

Giovanni Battista **Moroni** born Albino c 1525, died Bergamo 1578 Portrait of a Man, 'The Tailor' c 1571 canvas 97.8×74.9 Purchased 1862

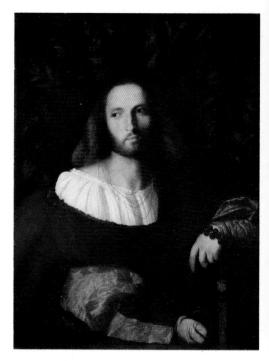

Palma Vecchio born Bergamo c 1480, died Venice 1528 *Portrait of a Poet, probably Ariosto* 1515/16(?) wood 83.8 × 63.5 Purchased 1860

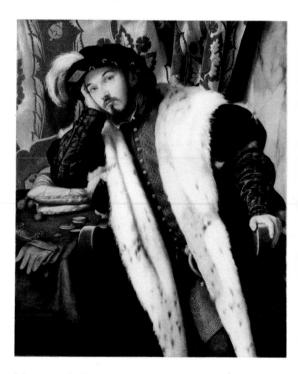

Moretto da Brescia born and died Brescia, c 1498–1554 *Portrait of a Young Man* c mid 1530s/mid 1540s canvas 113.7×94 Inscribed in Greek : 'Alas, I desire too much' Purchased 1858

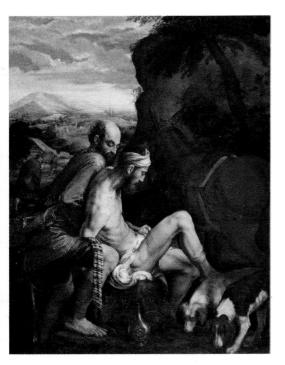

Jacopo dal Ponte called Jacopo **Bassano** born and died Bassano, c 1510/18-1592*The Good Samaritan* a middle period work canvas $101:5 \times 79.4$ Purchased 1856

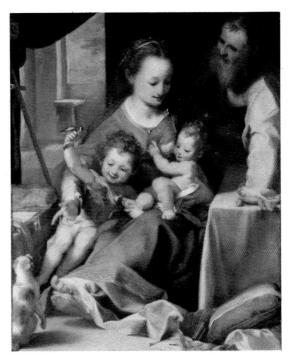

Federico **Barocci** born and died Urbino, 1535–1612 *Holy Family with the Infant Baptist, 'La Madonna del Gatto'* c 1577 canvas 112.7 × 92.7 Bequeathed 1831

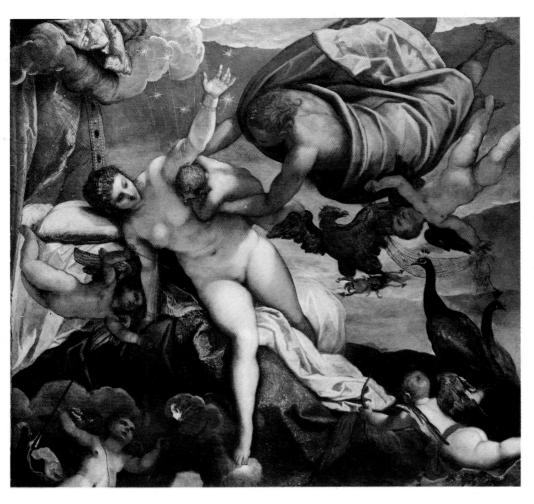

Jacopo Robusti called **Tintoretto** born and died Venice, 1518–1594 *The Origin of the Milky Way* late 1570s(?) canvas 148 × 165.1 Purchased 1890

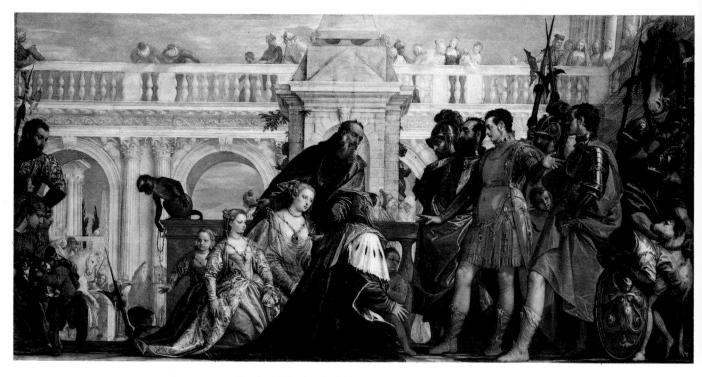

Jacopo Robusti called **Tintoretto** born and died Venice, 1518-1594St George and the Dragon 1560s(?) canvas 157.5×100.3 Bequeathed 1831 Paolo Caliari called **Veronese** born Verona probably 1528, died Venice 1588 *The Family of Darius before Alexander* late 1570s(?) canvas 236.2 × 474.9 Purchased 1857

Paolo Caliari called **Veronese** born Verona probably 1528, died Venice 1588 *The Vision of St Helena* an early work(?) canvas 197.5×115.6 Purchased 1878

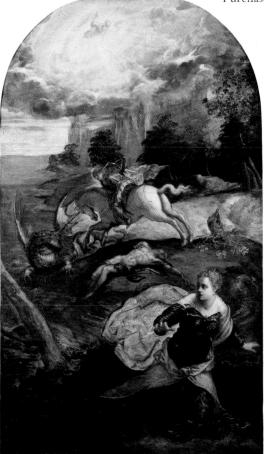

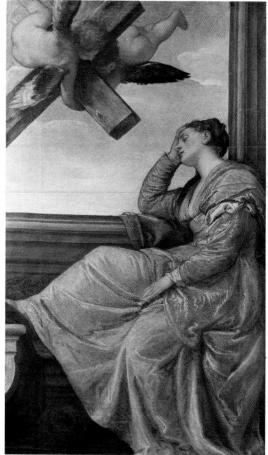

The collection of seventeenth-century Dutch and Flemish painting is second only to the Italian collection in range and quality. The Gallery now has, for example, twenty-two works by Rembrandt and twenty by Rubens, although until the second half of the nineteenth century the Dutch School was very poorly represented. With only a few exceptions, Dutch artists were not amongst those collected by the English on the European Grand Tour in the eighteenth century, and the only Dutch pictures in the Angerstein collection were two by Rembrandt and Cuyp's *Hilly River Landscape* (p 67). Among Holwell Carr's pictures, was Rembrandt's *Woman bathing in a stream* (p 64) but critics bemoaned the absence of more characteristic representatives of the School, such as Hobbema and Ruisdael.

Rubens had been popular with English collectors throughout the eighteenth century and was from the first well represented in the Gallery. Since his visit to London in 1629/30 his influence on English artists had been strong; it is apparent particularly in the work of Gainsborough and Reynolds. Classicism, which was at no time so authoritative a movement in England as it was in France, never really threatened Rubens' reputation. '*Peace and War*' (p 72) which was presented to the Gallery in 1828 by the Duke of Sutherland, was painted in England as a present from Rubens to Charles I. It is an allegory of the diplomatic mission that brought him to England, showing Minerva (or Wisdom) defending Peace and her train against Mars (the god of War) and the destructive Furies.

Another Flemish painter with particular connections with England, who, like Rubens, was represented in Angerstein's collection, is Van Dyck. Charles I appointed him as his Court painter in 1632 and it was in London that he died. One of the Gallery's largest pictures is the *Equestrian Portrait of Charles I* (p 75) executed for the King towards the end of the 1630's and purchased in 1885. The landscape background and loose painterly handling established the format for British portraiture until the end of the nineteenth century.

Virtually every aspect of the work of both Rubens and Van Dyck is now represented at the National Gallery. The *Autumn Landscape* (p 73), which formed part of Sir George Beaumont's gift and shows Rubens' own house is the chief of a number of fine landscapes, which later find an echo in Gainsborough's *Watering Place* (p 105). The *Woman and Child* (p 74) illustrates Van Dyck's early portrait style while he was still living at Antwerp. Another pupil of Rubens, Jacob Jordaens, is represented by both religious works and the superb double portrait of Govaert van Surpele and his wife (p 76) purchased in 1958.

It was only in the nineteenth century that many Dutch artists, the realistic painters of northern landscape like Ruisdael and Hobbema (as opposed to the Italianate landscapists such as Both and Berchem whose popularity dates from the eighteenth century), began to be appreciated in England. Their fidelity to nature and absence of idealisation, coupled with their detailed finish appealed to a new type of collector, to the professional or merchant classes who, not until the nineteenth century, began to play a significant role as arbiters of taste. Sir Robert Peel, who played such a large part in the Gallery's early history, came from a wealthy manufacturing family and built one of the most notable collections of Dutch pictures in the country during the first half of the century. Mrs Anne Jameson, herself an enthusiast for such painting, described Peel's collection in her *Private Galleries of Art in London* of 1844 as 'the most remarkable and valuable collection with which I am acquainted'.

It was this collection that formed the basis of the Dutch collection at the

National Gallery. Seventy-seven pictures, fifty-five of them Dutch, and eighteen drawings were bought in 1871 from the Peel collection for a total of \pounds 75,000. They included Hobbema's masterpiece *The Avenue, Middelharnis* (p 71), two fine de Hooghs, an *Interior* and *The Courtyard of a House* (p 68), Metsu's *Man and Woman beside a Virginal* (p 69) and Rubens' famous 'Chapeau de Paille' (p 74), a portrait of his wife's sister Susanna Fourment.

Five years later Wynn Ellis, a silk manufacturer and Free Trade Liberal, left his collection of 403 pictures to the Gallery. Ninety-four were selected and the rest sold. The majority were once again Dutch and show the collector's preference for realistic 'well-made' pictures. They include works by Ruisdael, for example his *Landscape with a Ruined Castle and a Church* (p 71), van de Cappelle, van de Velde and van der Heyden, and Berchem's *A Man and Youth ploughing* (p 66), which had once belonged to the French painter Boucher.

In 1910 the third considerable group of Dutch pictures came to the Gallery as part of the bequest of George Salting, which included fine works of most schools. The *Woman seated at a Virginal* (p 69), the second and last painting by Vermeer to be acquired, was the most important work in his collection. It joined the *Woman standing at a Virginal* (p 70) already in the Gallery, and the two paintings may indeed be a pair representing sacred and profane love. They had both formerly belonged to the critic and writer Théophile Thoré whose articles in the *Gazette des Beaux-Arts* in 1866 had led to a renewed appreciation of this rare artist. Among the remaining works in Salting's collection were paintings by Cuyp, Metsu, Jan Steen, Ruisdael, Frans Hals, including his *Portrait* of a Man (p 64), and Saenredam's Interior of the Grote Kerk, Haarlem (p 65).

Unlike other Dutch artists, Rembrandt has always been admired and appreciated, and throughout its history the Gallery has acquired examples of his work. Today Rembrandt's enormous range is well represented. The religious works include episodes from the life of Christ and the large and dramatic Old Testament scene, *Belshazzar's Feast* (p 65). Among fine examples of his portraiture are his self-portraits, one painted in 1640, the other (p 64) some thirty years later shortly before his death.

The Gallery has continued to buy works by major Dutch and Flemish artists. In selling to a national collection by private treaty both owner and gallery are subject to favourable terms, and important paintings are preserved for the nation. Three major works have been acquired in this way in the past decade, Koninck's *Extensive Landscape* (p 67), Rembrandt's portrait of his mistress *Hendrickje Stoffels* (p 63) and most recently a double portrait of *Lady Elizabeth Thimbelby and Dorothy Viscountess Andover* by Van Dyck.

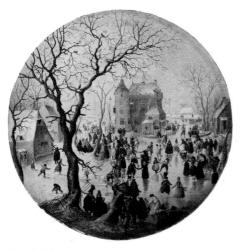

Hendrick **Avercamp** born Amsterdam 1585, died Kampen 1634 *A Winter scene with Skaters near a Castle* an early work wood diameter 40.7 signed Purchased 1891

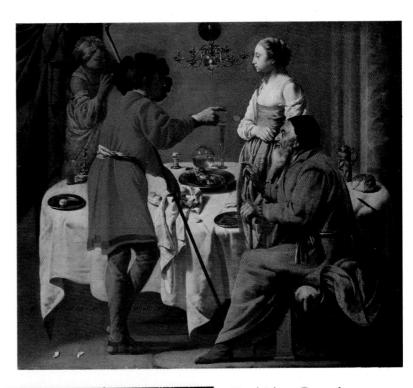

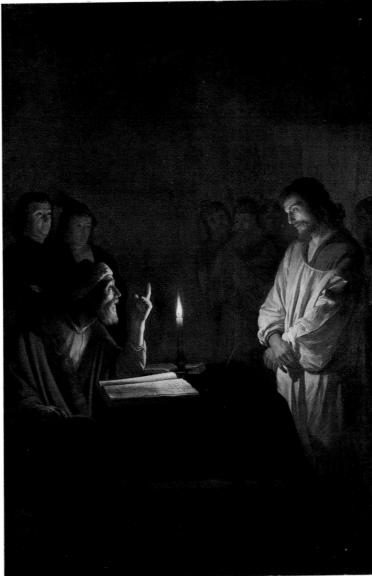

Hendrick ter **Brugghen** born 1588(?), died Utrecht 1629 *Jacob reproaching Laban* 1627 canvas 97.5 × 114.3 signed and dated Purchased 1926

Gerrit van **Honthorst** born and died Utrecht, 1590–1656 *Christ before the High Priest* c 1617(?) canvas 269.2 × 182.9 Purchased 1922

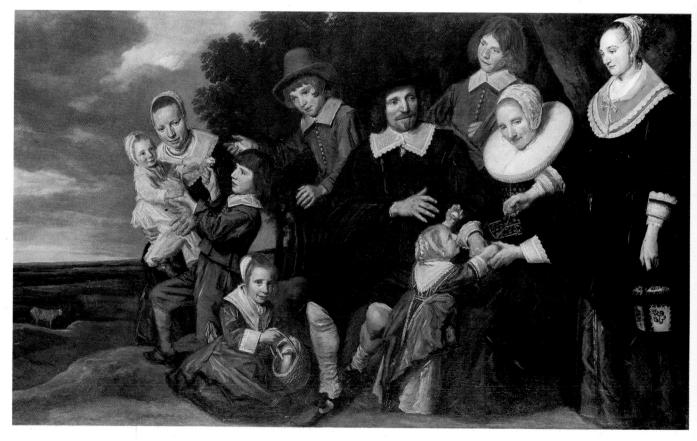

Frans **Hals** born Antwerp c 1580(?), died Haarlem 1666 *Family Group in a Landscape* late 1640s(?) canvas 148.5 \times 251 Purchased 1908

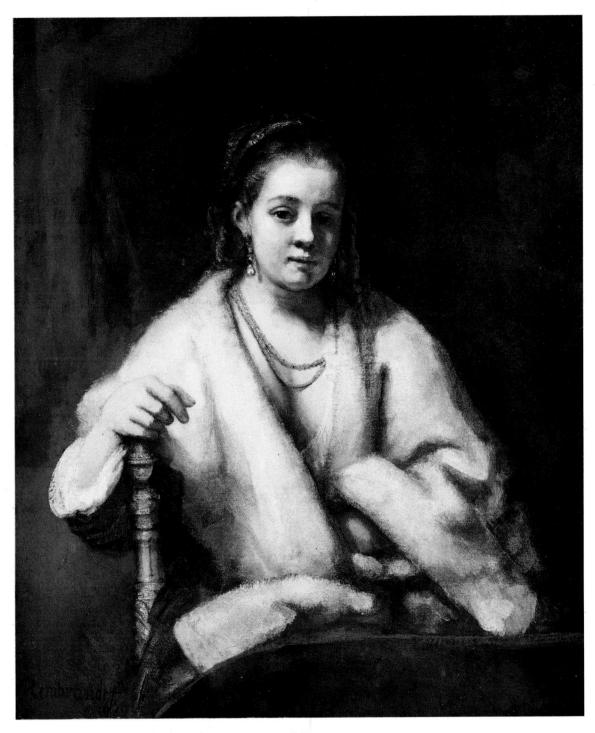

Rembrandt Harmensz van Rijn born Leyden 1606, died Amsterdam 1669 *Hendrickje Stoffels* 1659 canvas 101.9×83.75 signed and dated Purchased 1976

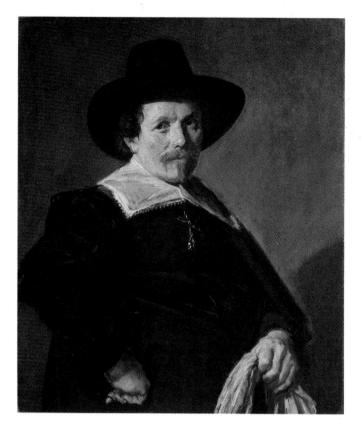

Frans **Hals** born Antwerp c 1580(?), died Haarlem 1666 *Portrait of a Man* mid 1640s(?) canvas 78.5 × 67.3 Bequeathed 1910

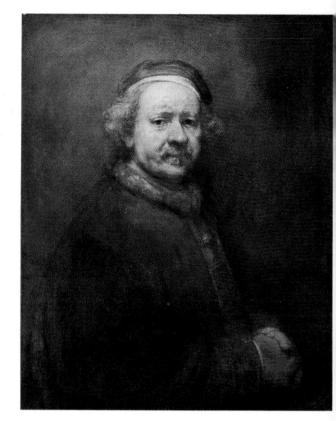

Rembrandt Harmensz van Rijn born Leyden 1606, died Amsterdam 1669 *Self-portrait aged Sixty-three* 1669 canvas 86 × 70.5 remains of a signature and dated Purchased 1851

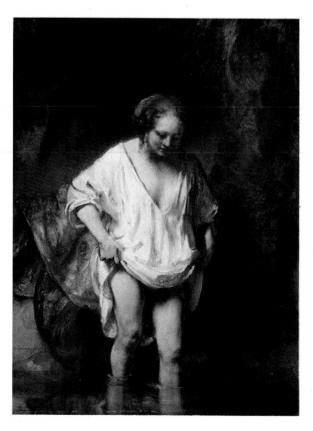

Rembrandt Harmensz van Rijn born Leyden 1606, died Amsterdam 1669 *Woman bathing in a Stream* 1655 wood 61.8×47 signed and dated Bequeathed 1831

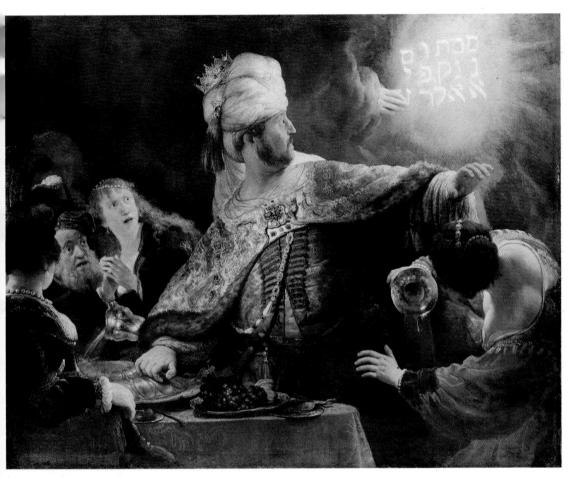

Rembrandt

Harmensz van Rijn born Leyden 1606, died Amsterdam 1669 *Belshazzar's Feast* 163(?) canvas 167.6 × 209.2 signed and dated Purchased 1964

Carel **Fabritius** born Midden-Beemster 1622, died Delft 1654 Self-portait 1654 canvas 70.5×61.6 signed and dated Purchased 1924

Pieter Saenredam

born Assendelft 1597, died Haarlem 1665 The Grote Kerk, Haarlem 1636/37 wood 59.5×81.7 Bequeathed 1910

Jan van **Goyen** born Leyden 1596, died The Hague 1656 *A View of Overschie* 1645 wood 66 × 96.5 signed and dated Bequeathed 1852

Jan van de **Cappelle** born and died Amsterdam, c 1623/25-1679*A Shipping Scene with a Dutch Yacht firing a Salute* 1650 wood 85.5×114.5 signed and dated Bequeathed 1876

Jan **Both** born and died Utrecht, c 1618(?)–1652

A Rocky Landscape with an Ox-cart canvas 120.5×160.5 signed Bequeathed 1902

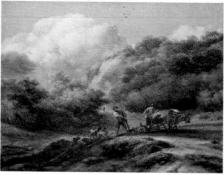

Nicolaes **Berchem** born Haarlem 1620, died Amsterdam 1683 A Man and Youth ploughing 1658 canvas 38.2×51.5 signed Bequeathed 1876

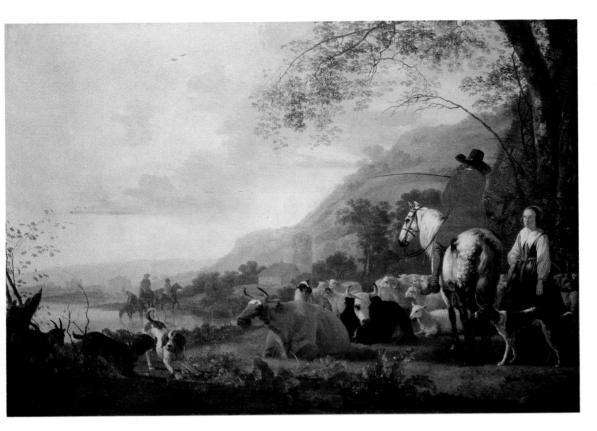

Aelbert Cuyp

born and died Dordrecht, 1620–1691 A Hilly River Landscape c 1655–66(?) canvas 135.2 × 200 signed Purchased 1824

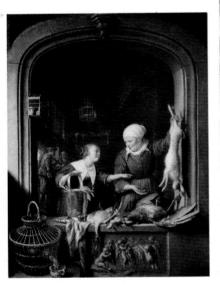

Gerrit **Dou** born and died Leyden, 1613–1675 *A Poulterer's Shop* a late work (?) wood 58 × 46 signed Purchased 1871

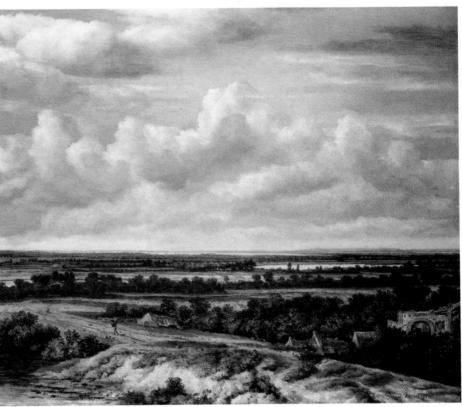

Philips **Koninck** born and died Amsterdam, 1619–1688 *Extensive Landscape with a Road by a Ruin* 1655 canvas 137.4×167.7 signed and dated Purchased 1971

Pieter de **Hoogh** born Rotterdam 1629, died Amsterdam after 1684(?) *The Courtyard of a House in Delft* 1658 canvas 73.5×60 signed and dated Purchased 1871

Nicolaes Maes born Dordrecht 1634, died Amsterdam 1693 Sleeping Maid and her Servant 1655 wood 70×53.3 signed and dated Bequeathed 1847

Adriaen van **Ostade** born and died Haarlem, 1610–1685 An Alchemist 1661 wood 34×45.2 signed and dated Purchased 1871

Jan **Steen** born and died Leyden, 1625/26-1679*Music making on a Terrace* c 1670 canvas 43.8×60.7 signed Purchased 1894

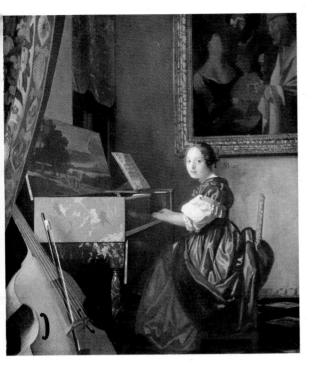

Johannes **Vermeer** born and died Delft, 1632–1675 *Young Woman seated at a Virginal* probably late 1670s canvas 51.5×45.5 signed Bequeathed 1910

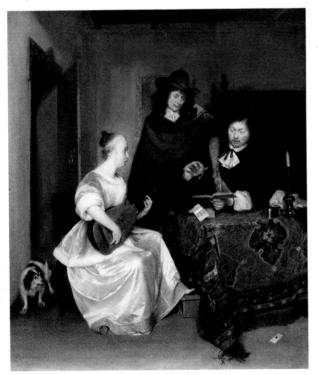

Gerard ter **Borch** born Zwolle 1617, died Deventer 1681 *A Woman making Music with two Men* probably c 1670 canvas 67.6 × 57.8 Purchased 1871

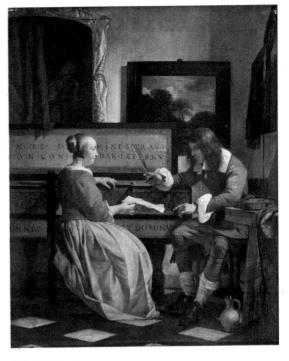

Gabriel **Metsu** born Leyden 1629, died Amsterdam 1667 *A Man and Woman beside a Virginal* probably late 1650s wood 38.4×32.2 Inscribed on the virginal from the Psalms (Vulgate: xxx.2, and LXX.1; cl.6) signed Purchased 1871

Jan van der **Heyden** born Gorinchem 1637, died Amsterdam 1712 *An Architectural Fantasy* late 1660s(?) wood 51.8×64.5 signed Bequeathed 1876

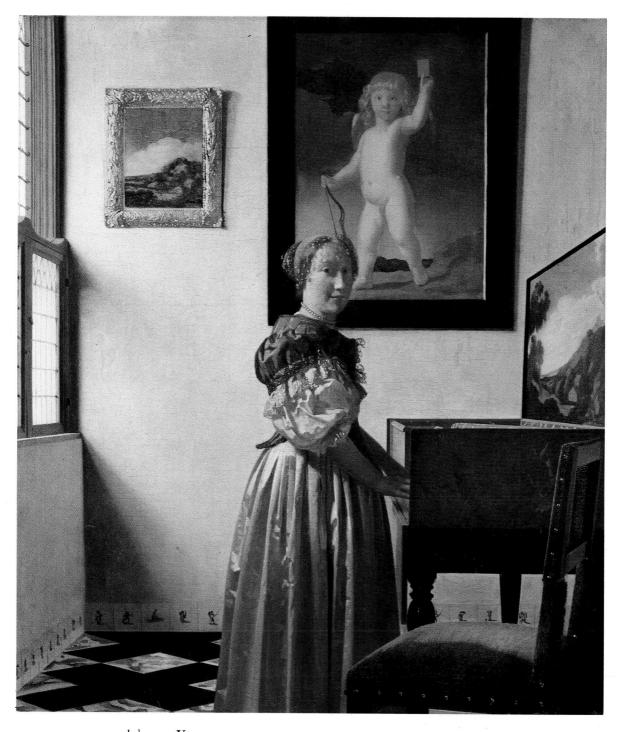

Johannes **Vermeer** born and died Delft, 1632–1675 *Young Woman standing at a Virginal* c 1670 canvas 51.7 × 45.2 signed Purchased 1892

Jacob van **Ruisdael** born and died Haarlem, 1628/29-1682*Landscape with a Ruined Castle and a Church* late 1660s canvas 109.2×146.1 signed Bequeathed 1876

Meyndert **Hobbema** born and died Amsterdam, 1638–1709 *The Avenue, Middelharnis* 1689 canvas 103.5 × 141 signed and dated Purchased 1871

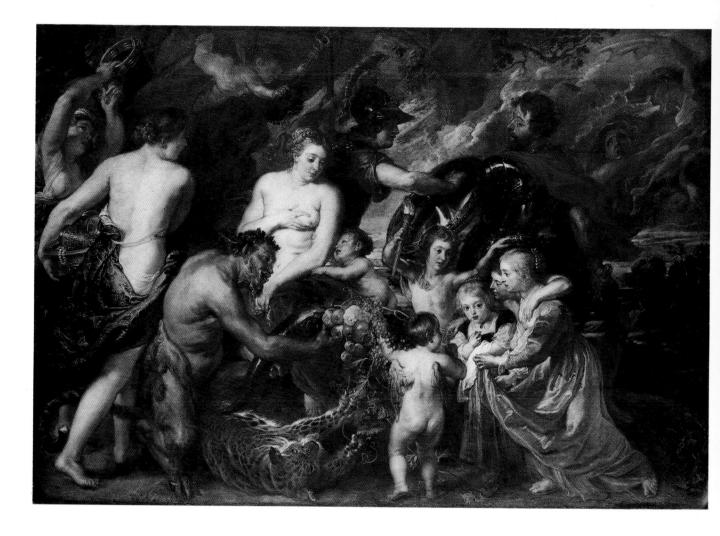

Peeter Pauwel **Rubens** born Siegen 1577, died Antwerp 1640 *Minerva protects Pax from Mars, 'Peace and War'* 1629/30 canvas 203.5×298 Presented 1828

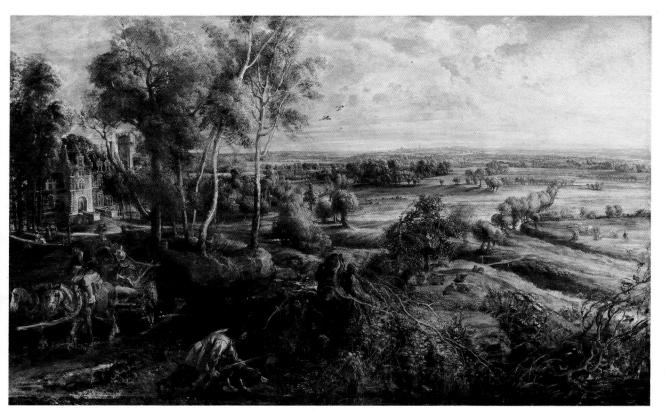

Peeter Pauwel **Rubens** born Siegen 1577, died Antwerp 1640 *Autumn Landscape with a View of Het Steen* 1636 wood 131.2 × 229.2 Presented 1823/28

Peeter Pauwel **Rubens** born Siegen 1577, died Antwerp 1640 *The Judgement of Paris* probably c 1632/35wood 144.8 × 193.7 Purchased 1844

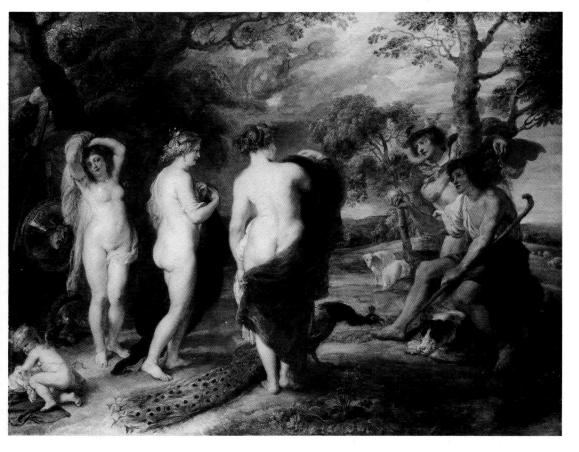

Peeter Pauwel **Rubens** born Siegen 1577, died Antwerp 1640 – *Susanna Lunden, 'Le Chapeau de Paille'* c 1622/25 wood 79 × 54 Purchased 1871

Anthony Van **Dyck** born Antwerp 1599, died London 1641 *A Woman and Child* 1620/21 canvas 131.5 × 106.2 Purchased 1914

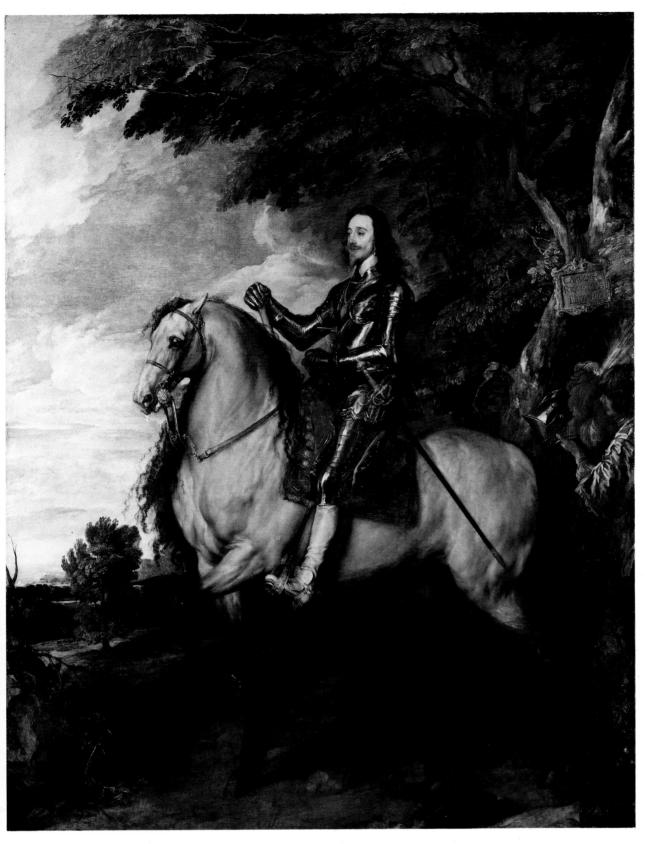

Anthony Van **Dyck** born Antwerp 1599, died London 1641 *Equestrian Portrait of Charles I* probably late 1630s canvas 367 × 292.1 Inscribed: CAROLVS/REX MAGNAE/BRITANIAE Purchased 1885

Jacob **Jordaens** born and died Antwerp, 1593–1678 *Govaert van Surpele and his Wife* c 1630/35(?) canvas 213.4 × 188.9 Purchased 1958

Jacob van **Oost I** born and died Bruges, 1601–1671 *A Boy aged Eleven* 1650 canvas 80:5 × 63 signed and dated Purchased 1883

Seventeenth-century Italy, France and Spain

The seventeenth century Bolognese painters, Guercino, Domenichino, Guido Reni and the Carracci, enjoyed a popularity among English collectors of the eighteenth century that is difficult to conceive today. There are still fine examples of their work in many private collections in the country but their names are now comparatively little known. They have long been held in poor favour and many of the Gallery's examples of their work were acquired early in its history, in the first half of the nineteenth century.

There were examples by these artists or their school among both the Angerstein and Holwell Carr pictures and in 1836 William IV himself presented two large mythological works which probably derive from the studio of Guido Reni. A very fine Annibale Carracci showing *Christ appearing to St Peter on the Appian Way* (p 80) was purchased in 1826, and in the 1840's began a whole spate of purchases in this school. One of the finest of these was the *Lot and his Daughters* (p 82) by Guido Reni but others were later found to be copies or poor studio versions. It was these unwise purchases together with the scandal over the cleaning of pictures that led to the Inquiry of 1853 and finally in 1855 to the revision of the Gallery's constitution.

But the attack upon the Gallery's policy of acquisition, in which Ruskin occupied a front-line position, ought to be seen in the wider context of the rediscovery of the primitives of both Italy and the North and the concomitant devaluation of seventeenth and eighteenth century painting. In the view of serious minds, Reni and Boucher were damned alike for their artificiality and lack of moral intention. A cloud of disrepute has since hung over the Bolognese painters, and the word 'eclectic' is used of them in a derogatory sense, implying an absence of originality. Although the qualities of these artists are not as immediately apparent as those of Caravaggio, a contemporary artist working further south in Italy, there is a fine sense of drama in both Annibale Carracci's 'Three Maries' (p 81) and Guercino's Incredulity of St Thomas (p 82). Differences of character are conveyed by the subtly varied poses and gestures, which are also designed to cohere in a formally satisfying composition. Caravaggio's unmistakable brand of realism is, on the other hand, arresting and aggresively dramatic, with strong contrasts of light and shade, as seen in his Supper at Emmaus (p 79).

Many foreign artists who trained in Italy, carried Caravaggio's influence all over Europe. In the German Elsheimer we find a new application of his light effects in very small and delicate paintings (p 81). In Naples, which in the seventeenth century was under Spanish possession, a whole generation of Italian and Spanish artists, including Giordano (p 83) and Ribera (p 92) adopted a style based on his work, and Velázquez, in such works as *The Kitchen Scene* (p 89) was already showing Caravaggio's influence before his visit to Italy in 1629/31. Among French artists too he had his followers. In *The Four Ages of Man* (p 82) by Le Valentin who was working in Rome in the 1620's, the raking light and chiaroscuro are derived from Caravaggio.

Claude and Poussin, the two most famous French artists of the century, both settled in Rome and died there. Claude is commonly regarded as the originator of the 'classical landscape' but while he refined it and made it popular, Domenichino had already painted many pictures in which landscape plays the chief part. Examples such as *Tobias and the Angel* (p 81) illustrate his preference for subjects which can be treated with figures subordinated to landscape. Although Claude also painted religious subjects many of his landscapes depict incidents from classical history or mythology. As in *Cephalus and Procris* (p 88) the real landscape around Rome is combined with buildings and vistas of an imagined golden age, one reason for the enormous popularity of Claude's paintings with English collectors in the eighteenth century. At a time when the gentry were cultivating a taste for things classical, and building villas in the Palladian style, his work proposed a vision of the landscape of the classical past which was imitated in countless parks and gardens.

Among Angerstein's pictures were five Claudes. Four more formed part of Sir George Beaumont's gift although the *Hagar and the Angel* (p 87), to which of all his pictures he was most attached, did not enter the collection until after his death in 1828. John Constable, a friend of Beaumont, copied this work and its influence can still be felt in *The Haywain* (p 114). In the eighteenth century and later, Claude, Poussin and Poussin's brother-in-law, Gaspard Dughet (several examples of whose work were among the Angerstein and Holwell Carr pictures) were much imitated by English landscapist painters. Turner in his early work produced virtual parodies of all three. Meanwhile it was Salvator Rosa (p 83) who provided a model for 'sublime' landscape and who, with his intensely dramatic treatment and irregular, rugged outlines particularly appealed to the romantic sensibility at the end of the eighteenth century.

The first Spanish artist to be represented in the National Gallery was Murillo, who for most of the nineteenth century was probably also the most popular. His *Peasant Boy* was presented to the Gallery in 1826 and the large canvas of *The Two Trinities* (p 94) was bought in 1837. Veláquez's *Boar Hunt*, purchased in 1846, was the first of his works to be acquired, and the stunning full-length *Portrait of Philip IV* (p 91) was purchased by Burton in 1882. El Greco, however, was little known until the end of the century. In 1895 the Gallery bought *Christ driving the Traders from the Temple* (p 90), which shows well his arresting style in which High Renaissance motifs, derived from Michelangelo, Titian, Tintoretto, are moulded into a totally personal idiom.

One of the greatest Spanish works in the collection and the only surviving nude by Velázquez, '*The Rokeby Venus*' (p 89), was presented to the Gallery in 1906 by the National Art-Collections Fund. This famous picture which had hung at Rokeby Park in Yorkshire for almost one hundred years, is painted with loose brush strokes and shows Velázquez freely improvising on the traditional theme of Venus at her mirror. It was the first major work of art to be saved by the Fund which raised $\pounds_{45,000}$ to acquire it.

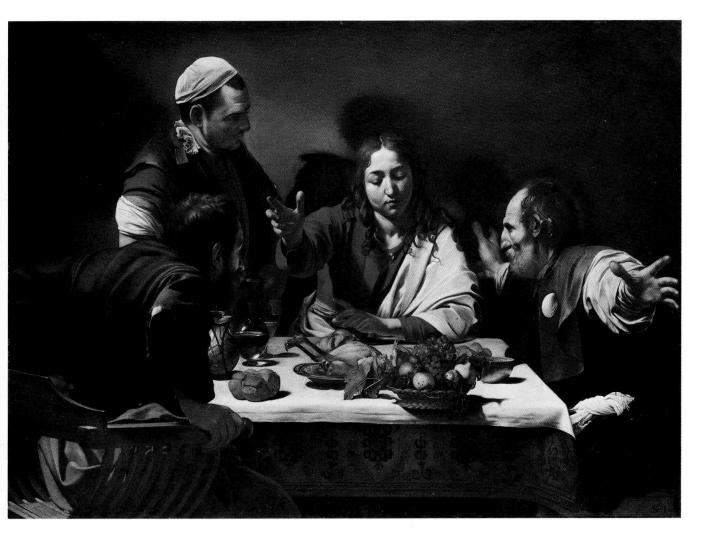

Michelangelo Merisi da **Caravaggio** born Caravaggio 1573, died Porto Ercole 1610 *The Supper at Emmaus* c 1596/1602(?) canvas 141 × 196.2 Presented 1839

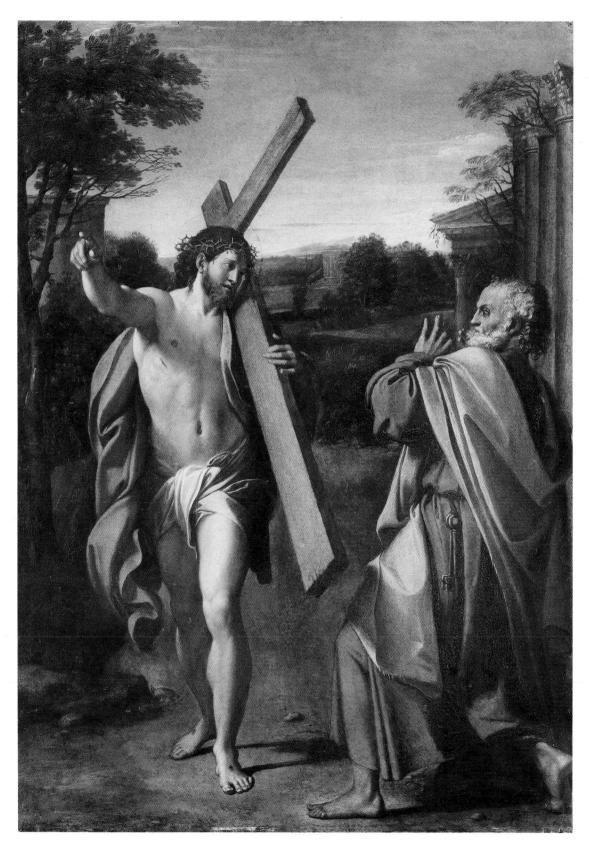

Annibale **Carracci** born Bologna 1560, died Rome 1609 *Christ and St Peter on the Appian Way, 'Domine, quo vadis?'* 1601/02 wood 77.4 × 56.3 Purchased 1826

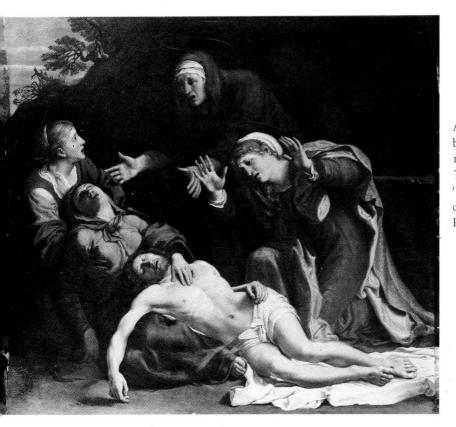

Annibale **Carracci** born Bologna 1560, died Rome 1609 *The Dead Christ Mourned, 'The Three Maries'* c 1604 canvas 92.8 × 103.2 Presented 1913

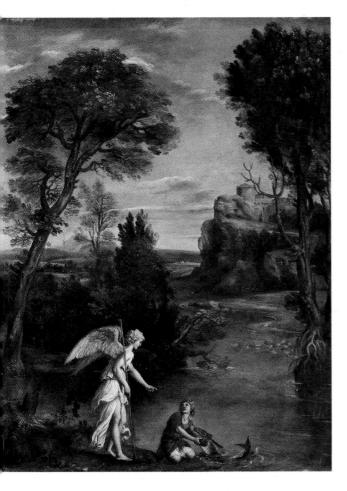

Adam **Elsheimer** born Frankfurt 1578, died Rome 1610 *Tobias and the Archangel Raphael* probably a late work copper 19.3 \times 27.6 Bequeathed 1894

Domenico Zampieri called **Domenichino** born Bologna 1581, died Naples 1641 *Landscape with Tobias and the Angel* c 1617/18copper 45.1 \times 33.9 Bequeathed 1831

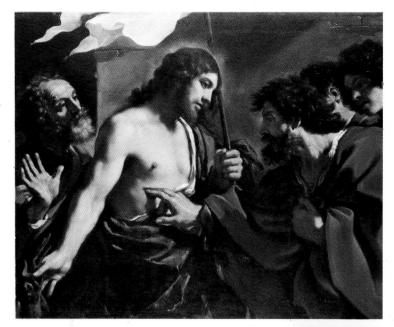

Giovanni Francesco Barbieri called **Guercino** born Cento 1591, died Bologna 1666 *The Incredulity of St Thomas* 1621 canvas 115.6×142.5 Purchased 1917

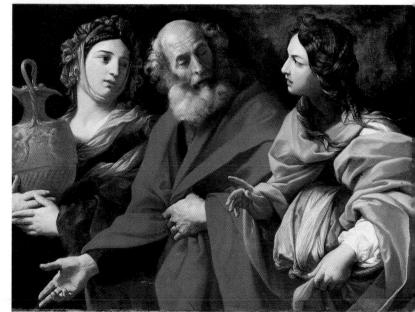

Guido **Reni** born and died Bologna, 1575–1642 Lot and his Daughters leaving Sodom c 1615/20 canvas 111.2×149.2 Purchased 1844

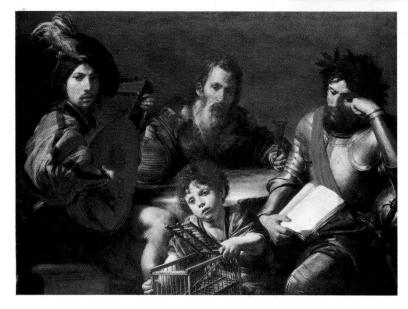

Le **Valentin** born Coulommiers 1591(?), died Rome 1632 *The Four Ages of Man* canvas 96.5 × 134 Presented 1938

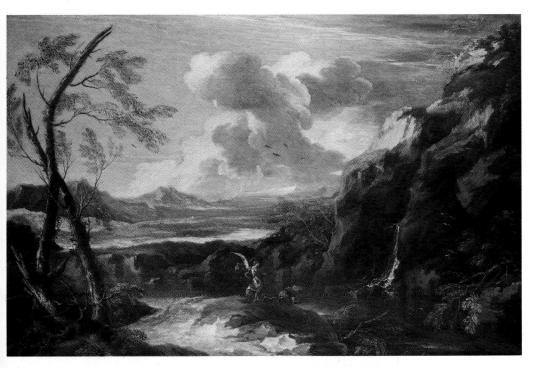

Salvator **Rosa** born Naples 1615, died Rome 1673 *Landscape with Tobias and the Angel* a late work(?) canvas 147.4 × 224 Purchased 1959

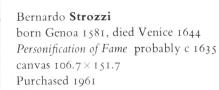

Luca **Giordano** born and died Naples, 1634–1705 *St Anthony of Padua* not later than 1700(?) canvas 105.5 × 80.3 Presented 1901

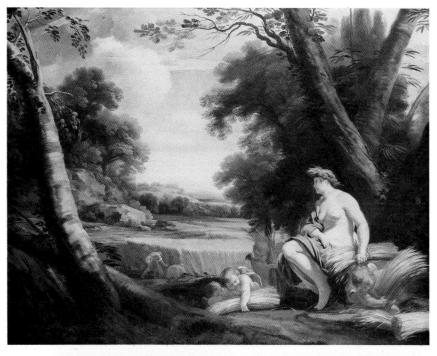

Simon **Vouet** born and died Paris, 1590–1649 *Ceres and harvesting Cupids* probably c 1634 canvas 147.6 × 188.7 Purchased 1958

Philippe de **Champaigne** born Brussels 1602, died Paris 1674 *Cardinal Richelieu* c 1640(?) canvas 259.7×177.8 signed Presented 1895

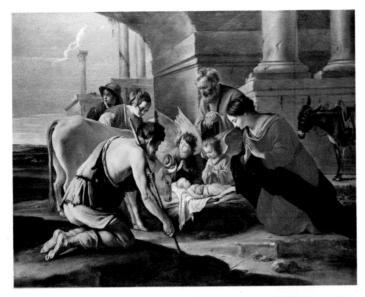

Louis Lenain born Laon c 1593, died Paris 1648 The Adoration of the Shepherds c 1640 canvas 109.5×137.4 Purchased 1962

Nicolas **Poussin** born Les Andelys 1594, died Rome 1665 *A Bacchanalian Revel* probably 1630s canvas 99.7×142.9 Purchased 1826

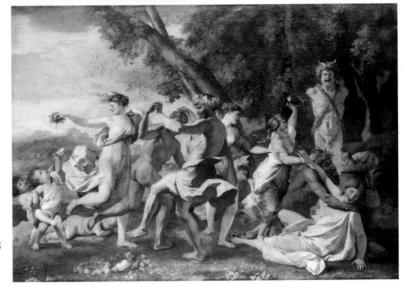

Nicolas **Poussin**

born Les Andelys 1594, died Rome 1665 Landscape with a Man killed by a Snake probably 1648 canvas 119.4 \times 198.8 Purchased 1947

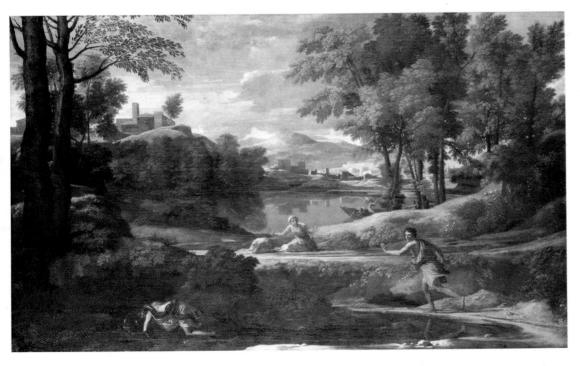

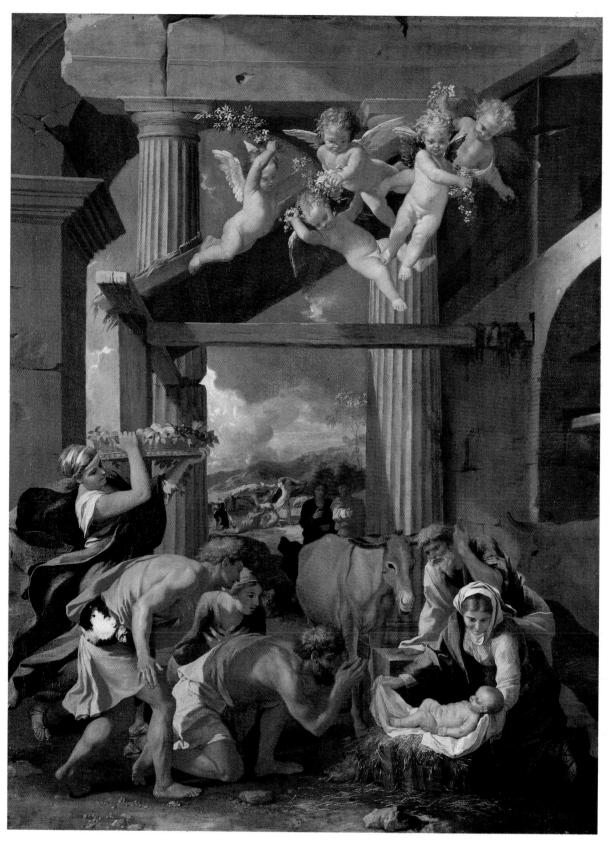

Nicolas **Poussin** born Les Andelys 1594, died Rome 1665 *The Adoration of the Shepherds* c 1637 canvas 96.5 × 73.7 signed Purchased 1957

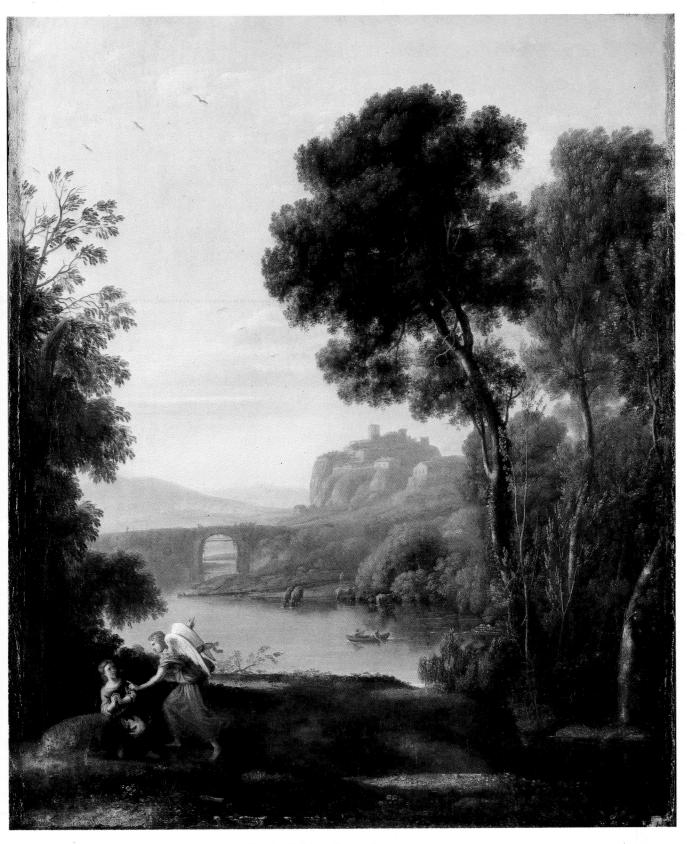

Claude Gellée called Le Lorrain born Champagne 1600, died Rome 1682 *Hagar and the Angel* 1646 canvas, mounted on wood 52.7×43.8 signed and dated Presented 1823/28

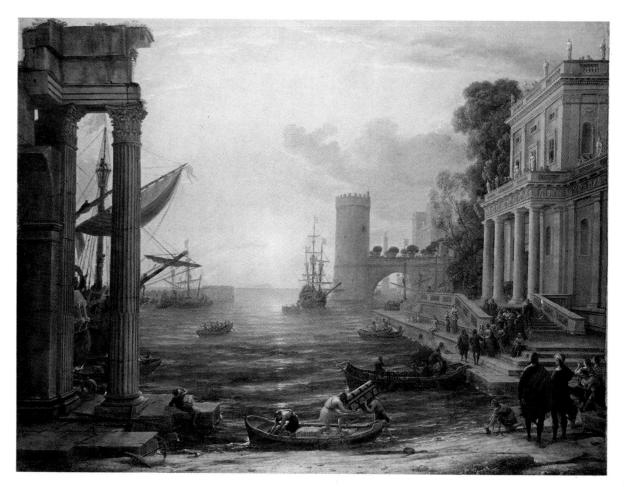

Claude Gellée called Le Lorrain born Champagne 1600, died Rome 1682 *Cephalus and Procris reunited by Diana*[®] 1645 canvas 101.6 × 132.1 signed and dated Purchased 1824 **Claude** Gellée called Le Lorrain born Champagne 1600, died Rome 1682 *The Embarkation of the Queen of Sheba* 1648 canvas 148.6 \times 193.7 signed and dated Purchased 1824

> Gaspard **Dughet** born and died Rome, 1615–1675 *Ariccia* an early work(?) canvas 49 × 66.7 Bequeathed 1831

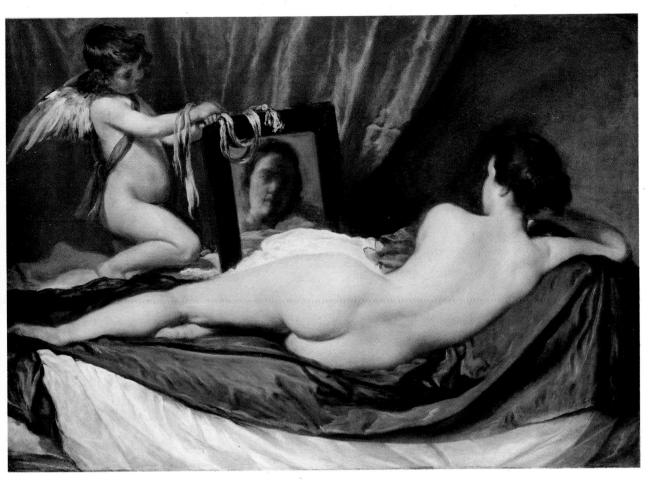

Diego Velázquez

born Seville 1599, died Madrid 1660 Kitchen Scene with Christ in the House of Martha and Mary 1618 canvas 60×103.5 dated Bequeathed 1892

Diego **Velázquez** born Seville 1599, died Madrid 1660 *The Toilet of Venus, 'The Rokeby Venus'* probably c 1648/49 canvas 122.5 × 177 Presented 1906

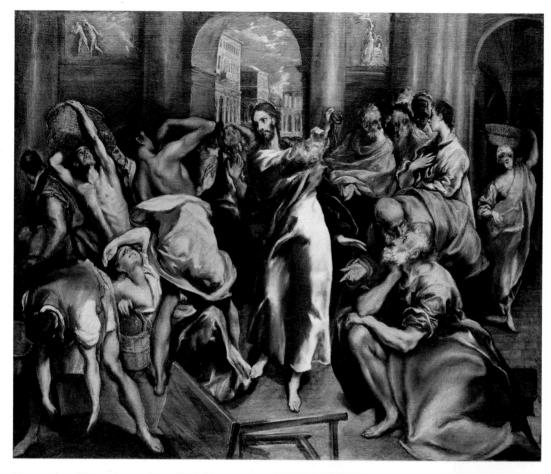

Domenikos Theotokopoulos called **El Greco** born Candia 1541, died Toledo 1614 *Christ driving the Traders from the Temple* probably c 1600 canvas 106.3 \times 129.7 Presented 1895

Domenikos Theotokopoulos called **El Greco** born Candia 1541, died Toledo 1614 *The Adoration of the Name of Jesus* probably c 1580 wood 57.8 × 34.2 signed Purchased 1955

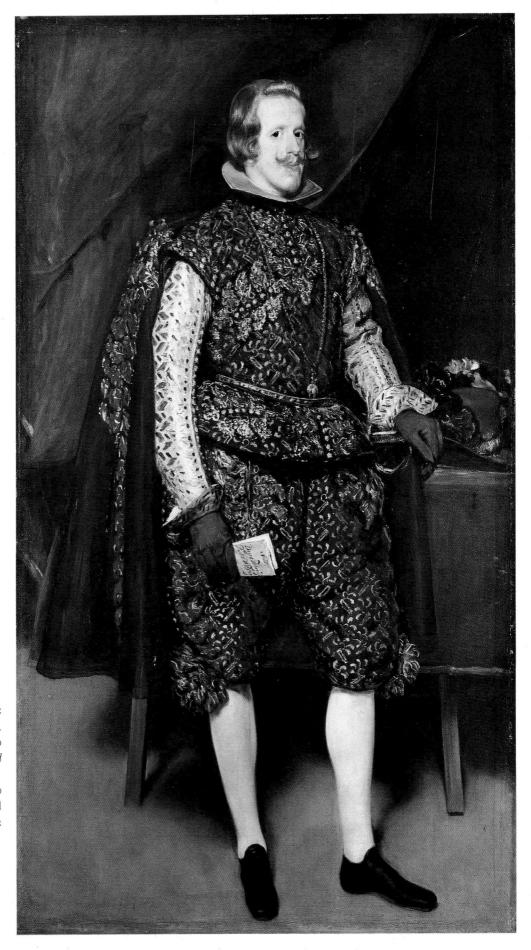

Diego **Velázquez** born Seville 1599, died Madrid 1660 Philip IV of Spain in Brown and Silver c 1631 canvas 195 × 110 signed Purchased 1882

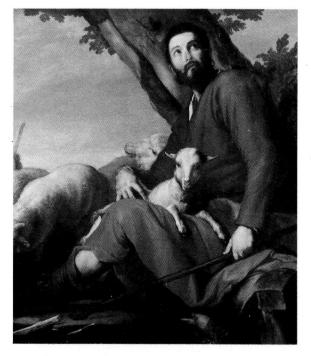

Jusepe de **Ribera** born Játiva 1591(?), died Naples 1652 *Jacob with the Flock of Laban* (fragment) 1638 canvas 132×118 signed and dated Bequeathed 1854

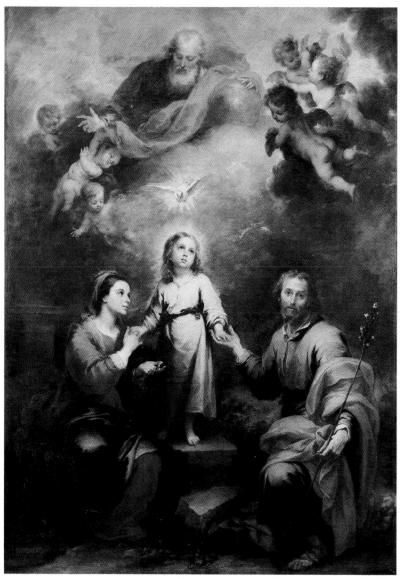

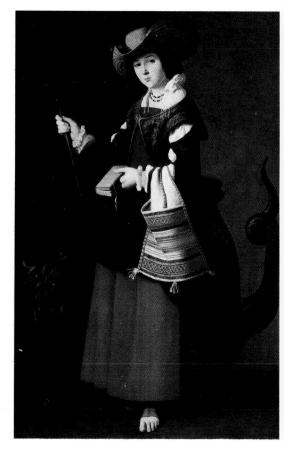

Francisco de **Zurbaran** born Fuente de Cantos 1598, died Madrid 1664 *St Margaret* probably early 1630s canvas 163×105 Purchased 1903

Bartolomé Esteban **Murillo** born and died Seville, 1617–1682 *The Two Trinities, 'The Pedroso Murillo'* c 1681/82 canvas 293 × 207 Purchased 1837

The Eighteenth Century

With the exception of British painters, particularly the portraitists who were directly employed by the aristocracy, and Canaletto, whose work was more popular with English buyers than with Italians, European artists of the eighteenth century have never been much favoured by English collectors. Consequently the eighteenth century is still thinly represented at the National Gallery despite recent purchases in this field.

During the Gallery's early years the only pictures of the previous century to enter the collection were Hogarth's series 'Marriage à la Mode' and Reynold's Lord Heathfield, all purchased in 1824 with the Angerstein pictures, Gainsborough's Watering Place (p 105), presented in 1827, two landscapes by Richard Wilson, part of the Beaumont gift, and one foreign picture, the famous Stonemason's Yard by Canaletto (p 97) which had also been in the Angerstein collection. Not until 1836, when four small pictures by Lancret representing The Ages of Man were accepted as part of the bequest of Lt Col Ollney, did the Gallery possess any example of French eighteenth-century painting, and acquisitions continued to be made with great infrequency, in most cases by gift or bequest.

Canaletto had been much admired in the eighteenth century for the detailed naturalism and accuracy of his views, which appealed to English collectors more than the playful and essentially untruthful illusionism of other Venetian painters. Many English visitors returned from Italy with examples of his work and during his visits to England in the 1740's and 50's he was much sought after to paint views of English country houses. So while many examples of his work were bequeathed to the Gallery in the nineteenth century, his contemporary, and probably the greatest Venetian painter of the eighteenth century, Giambattista Tiepolo, remained poorly represented. The ceiling painting showing *An Allegory with Venus and Time* (p 96), the only large-scale example of his decorative work in the Gallery, was purchased in 1969.

No effort was made in the nineteenth century to acquire French pictures because the Rococo, which had always been looked on with suspicion by the English, continued to be regarded as both frivolous and immoral. Although Hogarth, who visited Paris on more than one occasion, was indebted to French art for his delicate and fluid brushwork, he combines this with a strong satirical and moralising vein which distinguishes his work from the voluptuous mythologies of Boucher (p 102) and the charming domestic scenes of Lancret (p 102). At times Hogarth's satire is even directed specifically against the French, against their libertinism and superstition. In the nineteenth century, as a concern for morality grew stronger in England, so also did these prejudices, which were reinforced by patriotic feeling.

Nevertheless French Rococo did leave its imprint on English painting, particularly on the 'conversation piece' where groups are commonly shown in pastoral settings. French engravers, such as Philippe Mercier, and Gravelot, a pupil of Boucher, were responsible for disseminating in England through their prints, a type of composition which derives from the *fête galantes* of Jean-Antoine Watteau. Gainsborough was certainly familiar with their work and although *Mr and Mrs Andrews* (p 108) are depicted in contemporary dress with the wellregulated fields of their own estate spreading out behind, the type of composition and the elegant figures have their origin in such pictures as Watteau's '*Gamme d'Amour*' (p 100) where the setting is undefined and the figures masquerade in fancy costume. Gainsborough probably approaches closest to the French in his very late portraits such as *The Morning Walk* (p 106). Hardness and precise definition give way to an atmospheric evocation of place and mood, conveyed by loose feathery brushwork and silvery tones.

Fortunately the French eighteenth-century collection has lately been enriched by a number of important acquisitions. In 1972 what may be Lancret's masterpiece, 'La Tasse de Chocolat' (p 102), was bequeathed to the Gallery and an imposing portrait by Rigaud (p 99), one of the most important portraitists of the first half of the century, was purchased in 1975. Most recently, in 1976, a portrait by Perronneau of Jacques Cazotte (p 103) was purchased, which in its intimacy and spiritedness is entirely characteristic of its era.

The majority of the British pictures are today exhibited at the Tate Gallery but among the small selection that remains at Trafalgar Square are works of the highest quality. Reynolds can be seen both in the heroic mood of *General Sir Banastre Tarleton* (p 107), and in the more intimate vein of *The Countess of Albermarle* (p 108). The Gallery also possesses a striking and accomplished portrait by Sir Thomas Lawrence of Queen Charlotte, the wife of George III (p 109). Lawrence, who later became President of the Royal Academy, was only twenty when he painted this picture in 1789. A different type of English portraiture, more purely classical than that of Reynolds, Gainsborough or Lawrence, is exemplified by George Stubbs' *Milbanke and Melbourne Families* (p 104) which was purchased in 1975. In this group portrait he avoids all rhetoric, and succeeds solely by the careful positioning of each detail and the balancing of the tones, in conferring upon his sitters a calm and unassailable dignity.

At the end of the eighteenth century and beginning of the nineteenth century one of the greatest artists of the period, Francisco de Goya, was working at the Spanish Court in what had become an artistic backwater. Yet during his long life he witnessed the upheaval of Europe, and succeeded in chronicling the very great changes of thought and feeling that accompanied it. The small witchcraft scene (p 110), which was purchased in 1896, is no longer eighteenth century in feeling but seems to question man's ability to govern himself by reason. The subject is here drawn from a Spanish play, and, as in many of Goya's etchings, the real world is replaced by an imaginary one, peopled by frightening apparitions. *The Duke of Wellington* (p 100), purchased in 1961, is the last of his works to enter the collection. It was painted during Wellington's first visit to Madrid in 1812, when the British army liberated the city from the French, but some of the decorations were added subsequently.

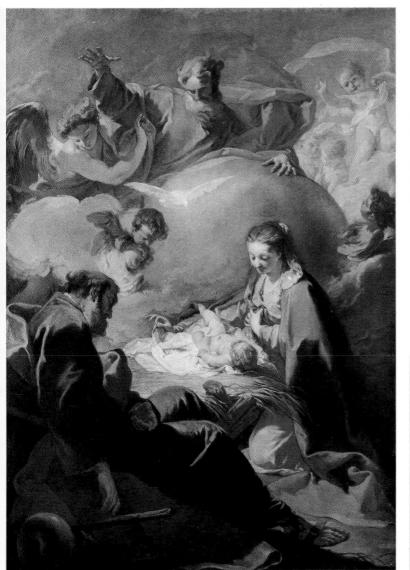

Giovanni Battista **Pittoni** born and died Venice, 1687–1767 *The Nativity with God the Father and the Holy Ghost* c 1740 canvas 222.7×153.5 Purchased 1958

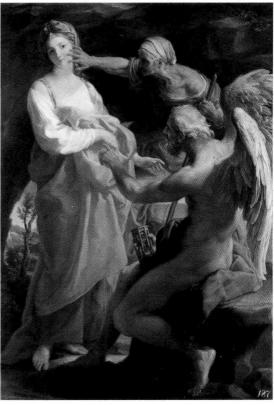

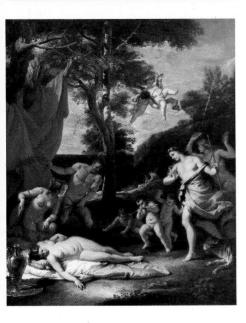

Sebastiano **Ricci** born Belluno 1659, died Venice 1734 *Bacchus and Ariadne* c 1710(?) canvas 75.9×63.2 Purchased 1871

Pompeo Girolamo **Batoni** born Lucca 1708, died Rome 1787 *Time orders Old Age to destroy Beauty* 1746 canvas 135.3×96.5 signed and dated Purchased 1961

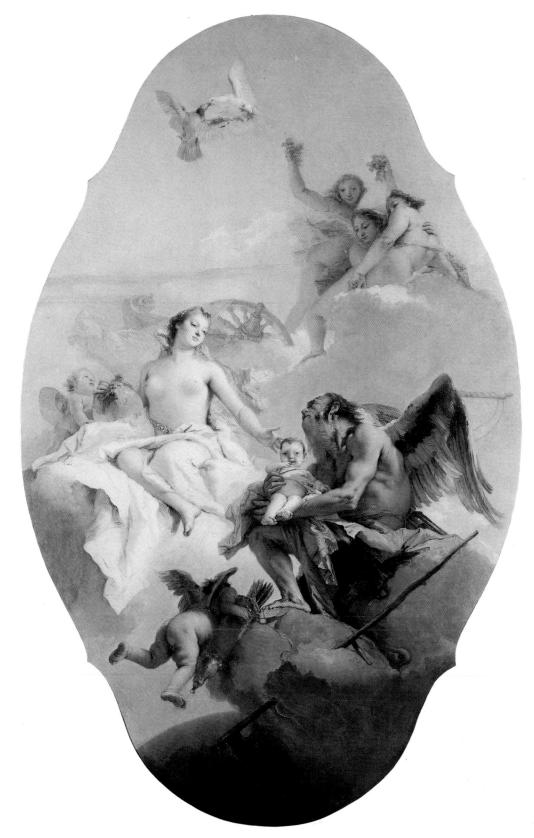

Giovanni Battista **Tiepolo** born Venice 1696, died Madrid 1770 *An Allegory with Venus and Time* c 1754 canvas 292.1 × 190.4 Purchased 1969

Giovanni Antonio Canal called **Canaletto** orn and died Venice, 1697–1768 Venice: Campo St Vidal and St Maria della Carità, 'The Stonemason's Yard' c 1730 canvas 123.8×162.9 Presented 1823/28

Giovanni Antonio Canal called **Canaletto** born and died Venice, 1697–1768 *Venice: The Basin of St Marco on Ascension Day* c 1735/41(?) canvas 121.9×182.8 Bequeathed 1929

Giovanni Battista **Tiepolo** born Venice 1696, died Madrid 1770 *The Banquet of Cleopatra* c 1745 canvas 44.2×65.7 Purchased 1972

Giovanni Domenico **Tiepol** born and died Venice, 1727–180 *The Procession of the Trojan Horse int Troy* (one of a series canvas 38.8×66 . Purchased 191

Pietro **Longhi** born and died Venice, 1702(?)–1785 *A Fortune-teller at Venice* 1756 canvas 59.1 × 48.6 signed and dated Purchased 1891

Francesco **Guardi** born and died Venice, 1712-17*A Caprice with Ruins on the Seashore* probably mid 1770s canvas 36.8×26.1 Bequeathed 1910

Hyacinthe **Rigaud** born Perpignan 1659, died Paris 1743 *Portrait of Antoine Paris* 1724 canvas 144.7 × 110.5 Purchased 1975

Jean-Marc **Nattier** born and died Paris, 1685-1766*Manon Balletti* 1757 canvas 54×45.7 signed and dated Bequeathed 1945

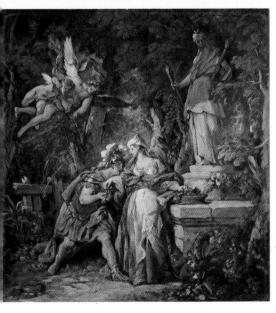

Jean-François **Detroy** born Paris 1679, died Rome 1752 *Jason swearing Eternal Affection to Medea* c 1743 canvas 56.5 × 52.1 Bequeathed 1962

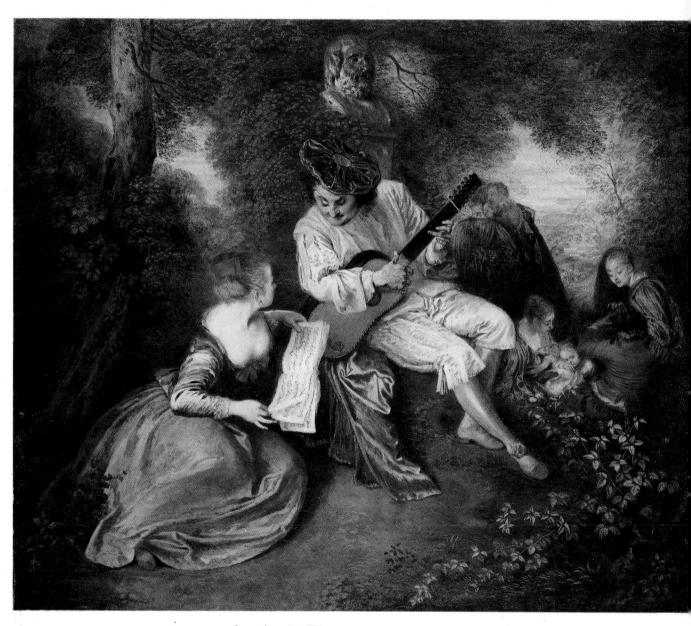

Jean-Antoine **Watteau** born Valenciennes 1684, died Nogent 1721 *'La Gamme d'Amour'* probably a late work canvas 50.8 × 59.7 Bequeathed 1912

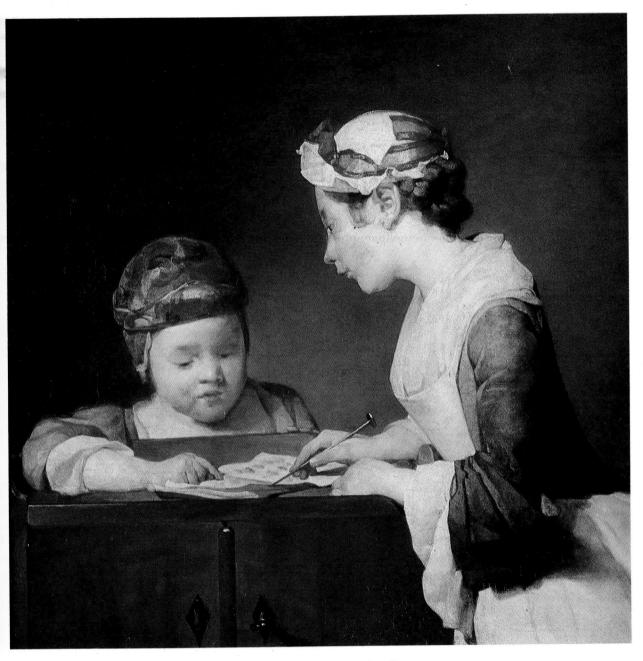

Jean-Baptiste Siméon **Chardin** born and died Paris, 1699–1779 *The Young Schoolmistress* 1740(?) canvas 61.6×66.7 Bequeathed 1925

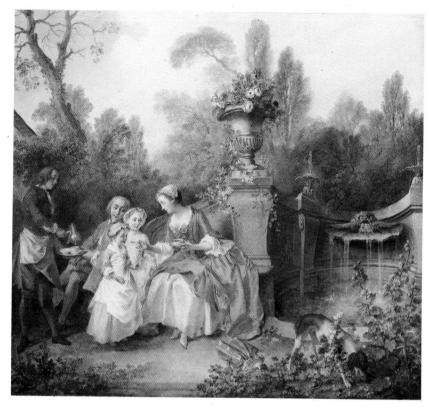

Nicolas Lancret

born and died Paris, 1690–1743 A Lady and Gentleman with Two Girls in a Garden, 'La Tasse de Chocolat' 1742 canvas 88.9 × 97.8 Bequeathed 1973

François **Boucher** born and died Paris, 1703–1770 *Landscape with a Watermill* 1755 canvas 57.2 × 73 signed and dated Purchased 1966

François **Boucher** born and died Paris, 1703–1770 *Pan and Syrinx* 1759 canvas 32.4×41.9 signed and dated Presented 1880

Jean-Baptiste **Perronneau** born Paris 1715(?), died Amsterdam 1783 *Portrait of Jacques Cazotte* canvas 89.5 × 71.9 Purchased 1976

Claude-Joseph **Vernet** born Avignon 1714, died Paris 1789 *A Sea-shore* 1776 copper 62.2×85.1 signed and dated Bequeathed 1846/47

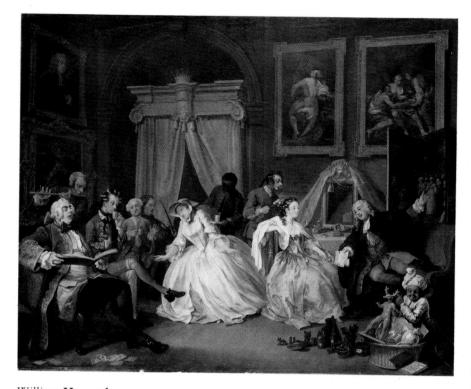

William **Hogarth** born and died London, 1697–1764 *The Countess's Morning Levée* (one of a series called '*Marriage à la Mode*') 1743 canvas 70.5 × 90.8 Purchased 1824

George Stubbs

born Liverpool 1724, died London 1806 The Milbanke and Melbourne Families c 1770 canvas 97.2×149.3 Purchased 1975 William Hogarth born and died London, 1697–1764 The Shrimp Girl (unfinished?) canvas 63.5×50.8

Purchased 1884

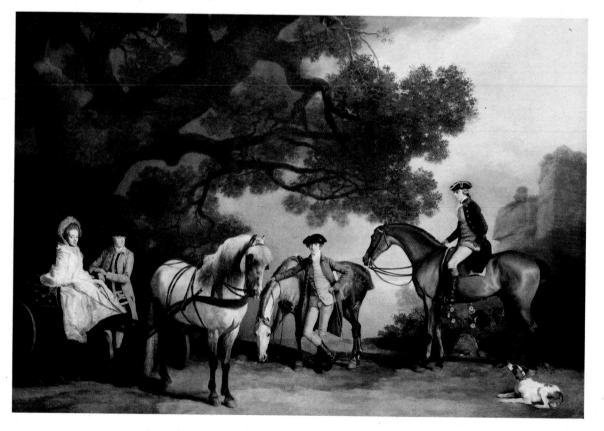

Richard **Wilson** born Penegoes 1713/14, died Colmmendy 1782 *Holt Bridge on the River Dee* 1762 canvas 148.5 × 193 Purchased 1953

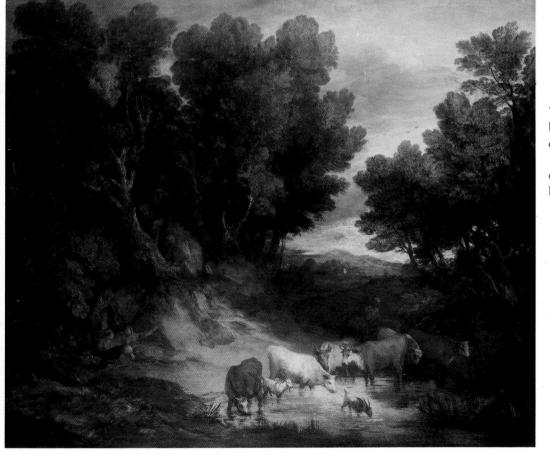

Thomas **Gainsborough** born Sudbury 1728, died London 1788 *The Watering Place* 1777 canvas 147.3×180.3 Presented 1827

105

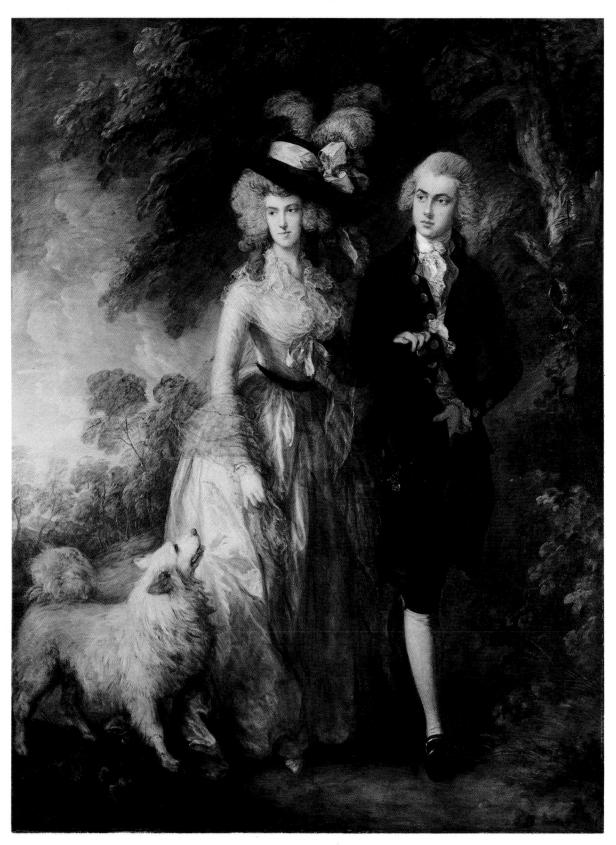

Thomas Gainsborough born Sudbury 1728, died London 1788 The Morning Walk 1785/86 canvas 236.3×179.1 Purchased 1954

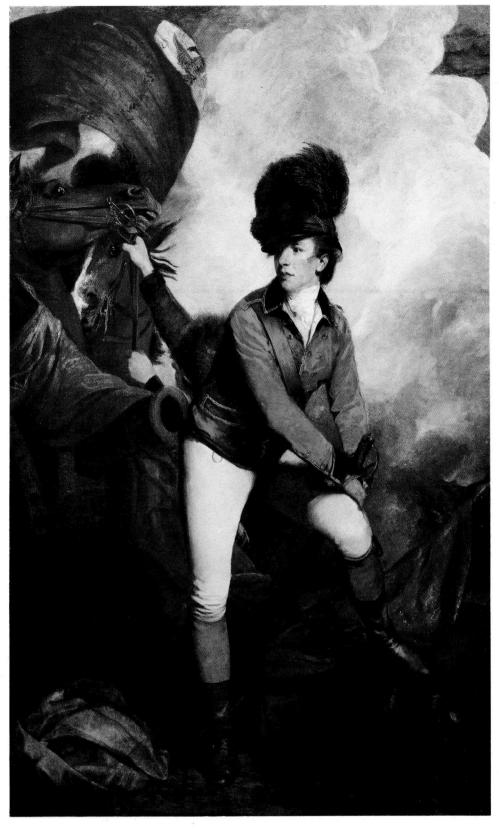

Sir Joshua **Reynolds** born Plympton 1723, died London 1792 General Sir Banastre Tarleton 1782 canvas 236.2×145.4 Bequeathed 1951

Sir Joshua **Reynolds** born Plympton 1723, died London 1792 *Anne, Countess of Albemarle* 1757(?) canvas 126.4 × 101 Purchased 1888/90

> Thomas **Gainsborough** born Sudbury 1728, died London 1788 *Mr and Mrs Andrews* c 1750 canvas 69.8 × 119.4 Purchased 1960

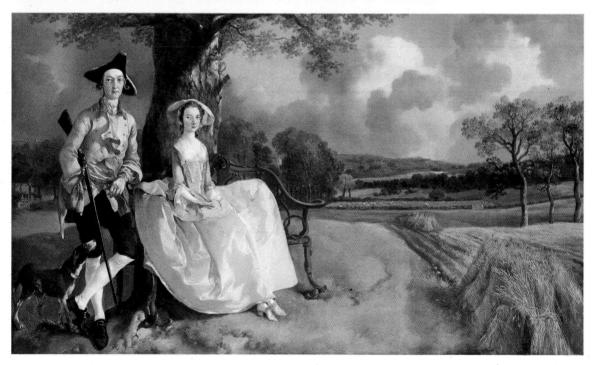

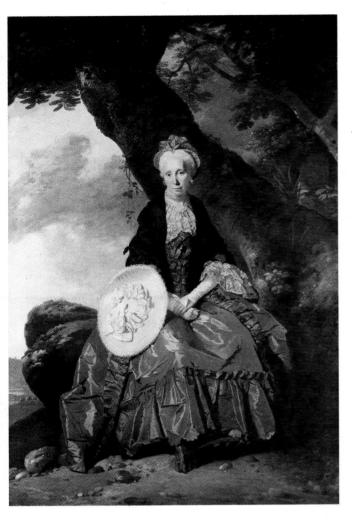

Johann **Zoffany** born Frankfurt on the Mein 1733 (?), died Strand-on-the-Green 1810 *Mrs Oswald* 1760(?) canvas 226.5 × 158.8 Purchased 1938

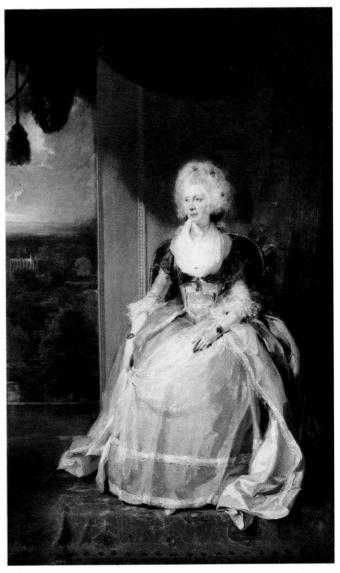

Sir Thomas **Lawrence** born Bristol 1769, died London 1830 *Queen Charlotte* 1789 canvas 239.4 × 147.3 Purchased 1927

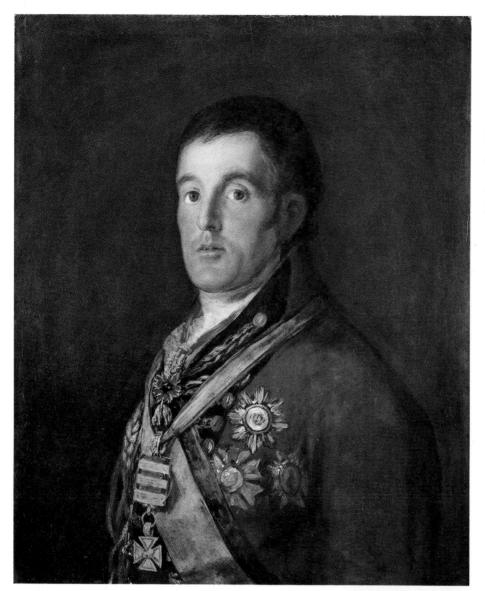

Francisco de **Goya** born Fuendetodos 1756, died Bordeaux 1828 *The Duke of Wellington* 1812/14 wood 64.3 × 52.4 Purchased 1961

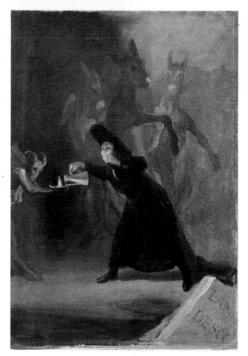

Francisco de **Goya** born Fuendetodos 1746, died Bordeaux 1828 *A Scene from ' The Forcibly Bewitched'* canvas 42.5 × 30.8 Purchased 1896

1800 Onwards

Despite increased efforts in recent years to make up the deficiency, the nineteenth century is undoubtedly one of the most poorly represented periods in the Gallery. There is still, for instance, no example of the work of Jacques-Louis David or the German Romantics, and such major painters of the first half of the century as Delacroix and Ingres are represented by only a handful of works. Yet at the time of the Gallery's foundation it was never suggested that the collection should exclude the work of contemporary artists. These gaps can fairly be attributed to the acquisition policy of those nineteenth-century directors, Eastlake, Boxall and Burton, who so enriched the Gallery's collection of Italian painting. By 1900, in fact, no painting by a foreign artist of the nineteenth century had been purchased, and the seven foreign works of this period that had been acquired as gifts or bequests, were all by artists who today are virtually forgotten.

Even the British collection had been formed without any considerable financial commitment. In 1847 the Vernon gift had contributed about 400 pictures, almost all British, and this was followed in 1856 by the Turner bequest of over 280 paintings and almost 2000 drawings and watercolours. Owing to the shortage of space at Trafalgar Square Vernon's pictures were first shown at his own house and later at Marlborough House where they were joined by the Turners. So from the beginning these modern works were segregated from the old masters which formed the core of the collection. In 1859 they moved to the new South Kensington Museum (now known as the Victoria and Albert Museum) and finally in 1897 to the Tate. Today only a small selection remains at Trafalgar Square, including Constable's Cornfield which was donated in 1837 by a group of the artist's admirers after his death, and such famous Turners as The 'Fighting Téméraire' (p 113) and Rain Steam and Speed (p 114). Two more of his works, Dido building Carthage and a harbour scene in which he emulates traditional modes of landscape, hang with the seventeenth-century French pictures between works by Claude, in accordance with Turner's wishes.

Neither Eastlake nor his successors seem to have had much sympathy or admiration for the modern continental schools of painting. 'A crying defect', Eastlake wrote, 'in all French painters, though perhaps not so much their fault as their country's, is that *goût libre* which is such a terrible abuse of the art and which our countrymen are happily free from, with one or two exceptions'. At the end of the century the Impressionists met with even greater contempt.

The French paintings which entered the Gallery as part of the Salting bequest in 1910 were not at that time either modern or avant-garde. Although he had chosen Dutch and Italian pictures with such discrimination, Salting's taste in nineteenth century works was conservative. Of these the majority were of the Barbizon school. They include paintings by T. Rousseau, Daubigny (p 118), and seven Corots. Also among the Salting pictures were two very fine oil sketches by Constable, a famous view of Weymouth bay and *Salisbury Cathedral* (p 114).

Sir Hugh Lane's collection which came to the Gallery on his death in 1917 was far more progressive in character, including a number of major Impressionist works. Although small in scale Manet's *Music in the Tuileries Gardens* (p 119) of 1862 shows the artist depicting contemporary life in a style which successfully avoids the sterile formulae of nineteenth century academic painting. In *The Umbrellas* (p 121) an important picture of twenty years later, Renoir shows a similar scene, but can be observed moving away from the blurred forms of his earlier works towards a more linear and structured art. Another of the Lane pictures was Avignon from the West (p 115) the finest Corot in the Gallery. Here, as a result of concentrated observation, he succeeds by the simplest of means, in assimilating all the varied forms of the landscape into a structural and tonal harmony.

Yet so unenthusiastic was the Trustees' response to Sir Hugh Lane's proposal to leave his collection to the Gallery that shortly before his death he changed his will and in an unwitnessed codicil left the pictures to the city of Dublin. Consequently, although legally the pictures belong to London, they are at present divided between the two cities.

Many of the Gallery's Impressionist pictures have been acquired through the generosity of another benefactor, Samuel Courtauld, who in 1923 in an effort 'to gain recognition of this School among the English public' gave $\pounds_{50,000}$ to set up a fund for the purchase of examples for the nation. Altogether just over twenty works were bought, including Monet's *Beach at Trouville* (p 120), Manet's *The Waitress* (p 119), Seurat's *Bathers, Asnières* (p 122), possibly the masterpiece of this short-lived artist, four paintings by Degas, and all four of the Gallery's van Goghs.

While in recent years the Gallery has continued to buy Impressionist works, it has also turned its attention to areas in the nineteenth century until now neglected. Although Ingres is represented by one of his greatest late portraits, *Madame Moitessier* (p 117), the Gallery has no major work by his contemporary and opponent Delacroix, yet in 1976 the Gallery succeeded in purchasing a small but highly characteristic Crucifixion (p 116). 'Le Douanier' Rousseau's *Tropical Storm with Tiger* (p 125) is the first painting by this artist to enter the collection, and more recently the Gallery has purchased, for the first time, works by the French Symbolist painters, Gustave Moreau and Odilon Redon and by Gustav Klimt, one of the leaders of the Vienna Secession. These important artists are still poorly represented in Britain; indeed, the portrait of *Hermine Gallia* (p 126) may be the only work by Klimt in the country. They deserve to be widely known and now at the National Gallery many more people will have the opportunity of seeing and enjoying their work.

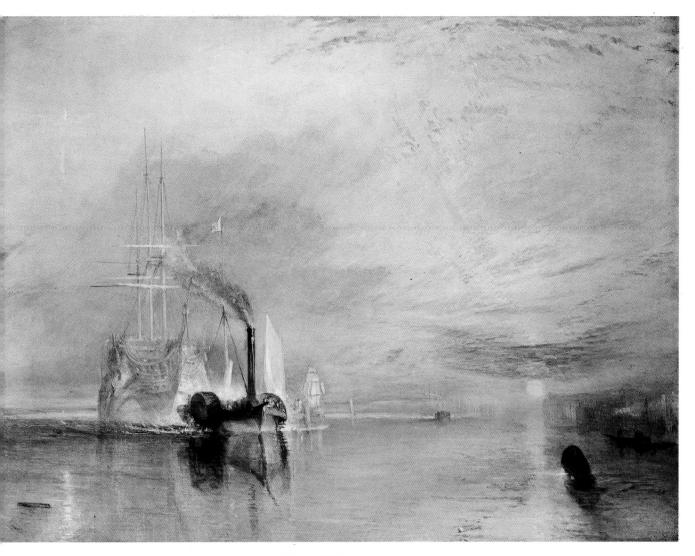

Joseph Mallord William **Turner** born and died London, 1775–1851 *The 'Fighting Téméraire'* 1838 canvas 90.8 × 121.9 Bequeathed 1856 Joseph Mallord William **Turner** born and died London, 1775–1851 *Rain, Steam and Speed – The Great Western Railway* 1844 canvas 90.8 × 121.9 Bequeathed 1856

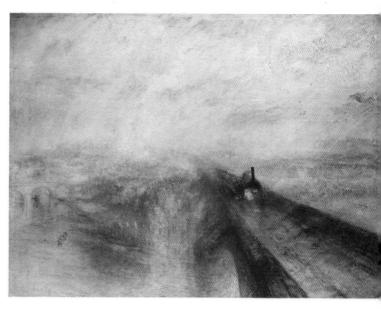

John Constable

born and died East Bergholt, 1776-1837The Haywain 1821 canvas 130.2×185.4 signed and dated Presented 1886

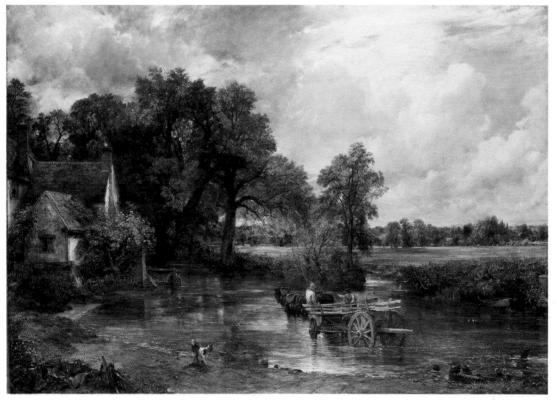

John **Constable** born and died East Bergholt, 1776–1837 *Salisbury Cathedral* (c 1820 canvas 52.7 × 76.8 Bequeathed 1910

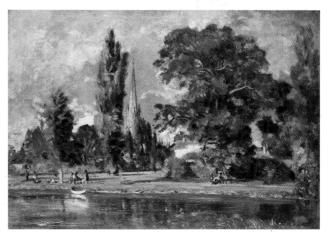

Jean-Louis-André-Théodore **Géricault** born Rouen 1791, died Paris 1824 *A Horse Frightened by Lightning* 1813(?) canvas 48.9 × 60.3 Purchased 1938

Jean-Baptiste-Camille **Corot** born and died Paris, 1796–1875 *Avignon from the West* c 1836 canvas 33.7×73 signed Bequeathed 1917

Paul **Delaroche** born and died Paris, 1795–1856 *The Execution of Lady Jane Grey* 1833 canvas 246×297 signed and dated Transferred from the Tate Gallery 1973

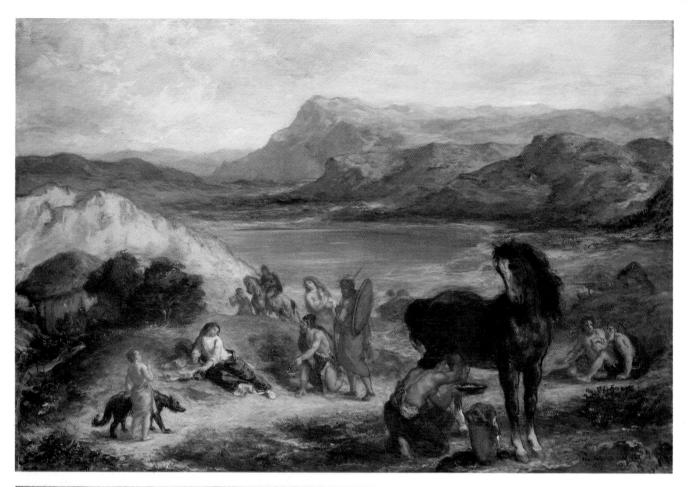

Ferdinand-Victor-Eugène **Delacroix** born and died Paris, 1798-1863*Ovid among the Scythians* 1859 canvas 87.6×130.2 signed and dated Purchased 1956

Ferdinand-Victor-Eugène **Delacroix** born and died Paris, 1798-1863*Christ on the Cross* 1853canvas 73.3×59.5 signed and dated Purchased 1976

Jean-Auguste-Dominique **Ingres** born Montauban 1780, died Paris 1867 *Madame Moitessier seated* 1856 canvas 120×92.1 Inscribed with the sitter's name signed and dated Purchased 1936

Honoré-Victorin **Daumier** born Marseilles 1808, died Paris 1879 *Don Quixote and Sancho Panza* (unfinished) wood 40.3 × 64.1 Bequeathed 1917

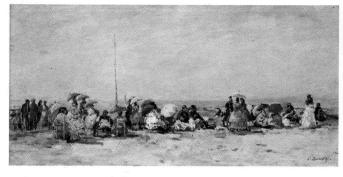

Louis-Eugène **Boudin** born Honfleur 1824, died Deauville 1898 *Beach Scene, Trouville* 1860s wood 21.6×45.8 signed Bequeathed 1960

Charles-François **Daubigny** born and died Paris, 1817–1878 *Willows* 187(4?) canvas 54.6 × 80 signed and dated Bequeathed 1910

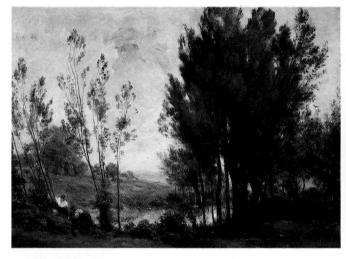

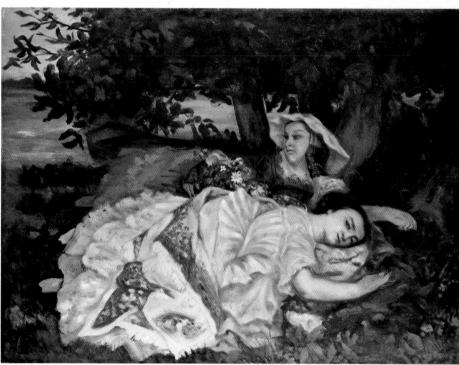

Jean-Désiré-Gustave **Courbet** born Ornans 1819, died 1877 La Tour de Peitz *The Girls on the Banks of the Seine* sketch for the painting exhibited in 1857 canvas 96.5 × 130 Purchased 1964

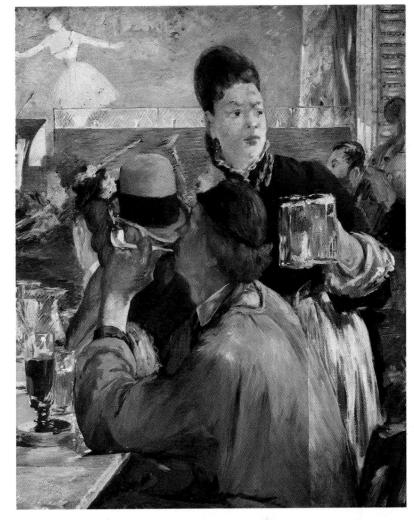

Edouard **Manet** born and died Paris, 1832–1883 *The Waitress* 1878/79 canvas 97.1 × 77.5 signed and dated Presented 1924

Edouard **Manet** born and died Paris, 1832–1883 *Music in the Tuileries Gardens* 1862 canvas 76.2 × 118.1 signed and dated Bequeathed 1917

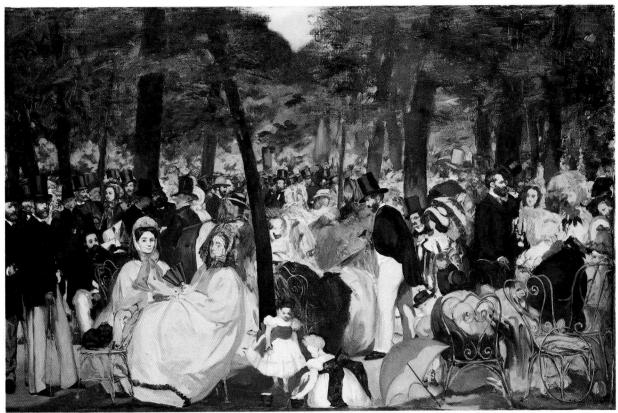

Claude-Oscar **Monet** born Paris 1840, died Giverny 1926 *The Beach at Trouville* 1870 canvas 37.5×45.7 signed and dated Presented 1924

> Alfred **Sisley** born Paris 1839, died Moret-sur-Loing 1899 *The Horse Trough at Marly* 187(?) canvas 49.5×65.4 signed and dated Presented 1926

Claude-Oscar **Monet** born Paris 1840, died Giverny 1926 *The Water-lily Pond* 1899 canvas 88.3 × 92.1 signed and dated Purchased 1927

Camille **Pissarro** born Virgin Islands 1830, died Paris 1903 *The Côte des Boeufs at L'Hermitage, near Pontoise* 1877 canvas 114.9 \times 87.6 signed and dated Presented 1926

Pierre-Auguste **Renoir** born Limoges 1841, died Cagnes 1919 *The Umbrellas* c 1880/85canvas 180.3×114.9 signed Bequeathed 1917

Vincent van **Gogh** born Groot-Zundert 1853, died Auvers-sur-Oise 1890 *Sunflowers* 1888 canvas 92.1 × 73 signed Presented 1924 Georges-Pierre **Seurat** born and died Paris, 1859-1891*Bathers, Asnières* 1883/84canvas 201×300 signed Presented 1924

Paul **Gauguin** born Paris 1848, died the Marquesas Islands 1903 *Flower-piece* 1896 canvas 64.1 × 74 signed and dated Purchased 1918

Hilaire-Germain-Edgar **Degas** born and died Paris, 1834–1917 *Princess Metternich* probably 1870 canvas 40.6 × 28.8 Presented 1918 Hilaire-Germain-Edgar **Degas** born and died Paris, 1834-1917*Combing the Hair* (unfinished) c 1885 canvas 114.3 \times 146.1 Purchased 1937

Henri de **Toulouse-Lautrec** born Albi 1864, died Château de Malrome 1901 *Woman seated in a Garden* 1891 millboard 66.7 × 52.8 Presented 1926

Paul **Cézanne** born and died Aix-en-Provence, 1839–1906 *Mountains in Provence* 1886/90 canvas 63.5 × 79.4 Purchased 1926

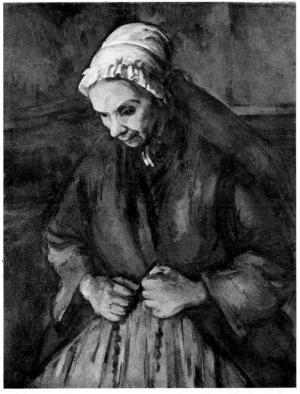

Henri **Rousseau** called 'le Douanier' born Laval 1844, died Paris 1910 *Tropical Storm with a Tiger* 1891 canvas 129.8 × 161.9 signed and dated Purchased 1972

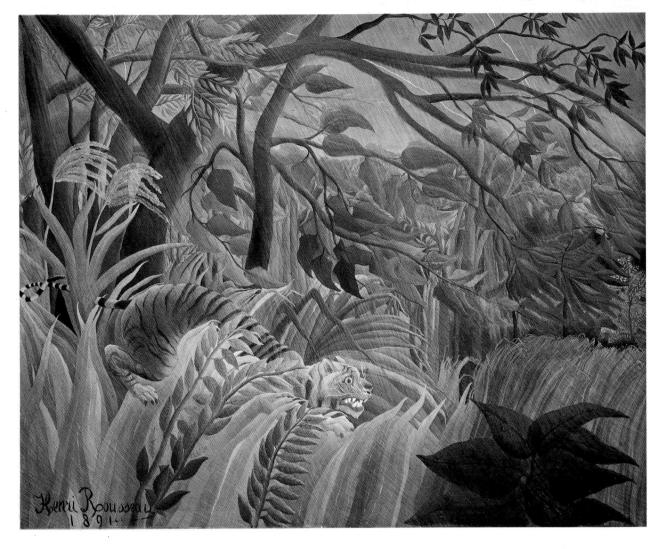

Edouard **Vuillard** born Cuiseaux 1868, died La Baule 1940 *The Chimney-piece* 1905 canvas 51.4×77.5 signed and dated Purchased 1917

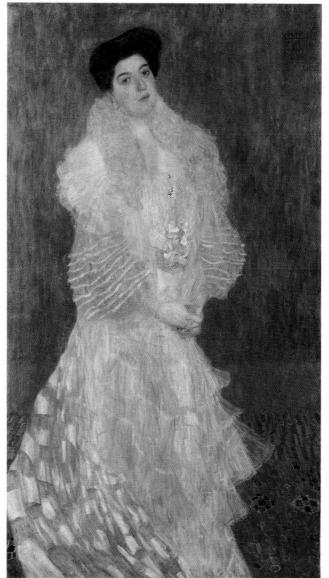

Gustav **Klimt** born and died Vienna, 1862–1918 *Hermine Gallia* 1904 canvas 170.5 × 96.5 signed Purchased 1976

- Altdorfer, Albrecht, Landscape with a Footbridge, 39 Angelico, Fra, Christ Glorified in the Court of Heaven, 16
- Angerstein, John Julius, 5–6, 9, 43, 44, 59, 77, 78, 93 Antonello da Messina, 27; Portrait of a Man, 22; St Jerome in his Study, 22
- Avercamp, Hendrick, A Winter Scene with Skaters near a Castle, 61
- Baldovinetti, Alesso, Portrait of a Lady, 17
- Baldung, Hans, 27; Portrait of a Man, 39
- Barocci, Federico, 43; Holy Family with the Infant Baptist, 57
- Barry, Sir Charles, 6
- Bartolommeo, Fra, 9
- Bassano, Jacopo, The Good Samaritan, 57
- Batoni, Pompeo, Time orders Old Age to destroy Beauty, 95
- Beaumont, Sir George, 5, 6, 9, 59, 78, 93 Bellini, Giovanni, 9, 27; The Agony in the Garden, 23; Doge Leonardo Loredan, 23; The Madonna of
- the Meadow, 9, 23 Berchem, Nicolaes, A Man and a Youth ploughing,
- 60,66 Borch, Gerard ter, A Woman making Music with two Men, 69

Bosch, Hieronymus, Christ mocked, 37

- Both, Jan, 59; A Rocky Landscape with an Ox-cart, 66 Botticelli, Sandro, 9; The Mystic Nativity, 25; Portrait of a Young Man, 25; Venus and Mars, 10, 25
- Boucher, François, 60, 77, 93; Landscape with a Watermill, 102; Pan and Syrinx, 102
- Boudin, Louis-Eugène, Beach Scene, Trouville, 118 Bouts, Dieric, The Entombment, 34
- Boxall, Sir William, 9, 43, 111
- Bramantino, The Adoration of the Kings, 22
- Bronzino, An Allergory, 50
- Brueghel, Pieter, the Elder, The Adoration of the Kinos. 37
- Brugghen, Hendrick ter, Jacob reproaching Laban, 61

Burton, Sir Frederick, 9, 78, 111

- Campin, Robert, 27; The Virgin and Child before a Firescreen. 30
- Campin, Robert, ascribed to, A Woman, 30 Canaletto, 93; The Basin of St Marco on Ascension Day, 97; 'The Stonemason's Yard', 93, 97
- Cappelle, Jan van de, 60; A Shipping Scene with a
- Dutch Yacht firing a Salute, 66 Caravaggio, 77; The Supper at Emmaus, 77, 79
- Caravaggio, 77; 1 ne Supper at Emmans, 77, 79 Carracci, Anibale, 9, 77; Christ and St Peter on the Appian Way, 77. 80; The Dead Christ Mourned, 'The Three Maries', 77, 81 Cézanne, Paul, Mountains in Provence, 124; An Old
- Woman with a Rosary, 125
- Champaigne, Philippe de, Cardinal Richelieu, 84 Chardin, Jean-Baptiste-Siméon, The Young Schoolmistress, 101
- Christus, Petrus, Portrait of a Young Man, 31
- Clima, 9; The Virgin and Child, 24 Claude Gellée, 5, 77, 78, 111; Cephalus and Procris reunited by Diana, 77, 88; The Embarkation of the
- Constable, John, 77, 88; 1 ne Embarkation of the Queen of Sheba, 88; Hagar and the Angel, 78, 87 Constable, John, 5, 78; The Cornfield, 111; The Haywain, 78, 114; Salisbury Cathedral, 111, 114 Corot, Jean-Baptiste-Camille, 111; Avignon from the West, 112, 115
- Correggio, 9; Antiope, 43; Ecce Homo, 43; The Madonna of the Basket, 43, 48; 'The School of Love', 43, 48
- Cossa, Francesco del, 9
- Costa, Lorenzo, A Concert, 19
- Courbet, Jean-Desiré-Gustave, The Girls on the Banks of the Seine, 118
- Courtauld, Samuel, 112
- Cranach, Lucas, the Elder, Cupid complaining to Venus, 41
- Crivelli, Carlo, 9; The Annunciation with St Emidius, 19
- Cuyp, Aelbert, 59, 60; A Hilly River Landscape, 67
- Daubigny, Charles-François, 111; Willows, 118 Daumier, Honoré-Victorin, Don Quixote and Sancho Panza, 118
- David, Gerard, The Adoration of the Kings, 35; Virgin and Child with Saints and Donor, 35

Index

- David, Jacques-Louis, 111 Degas, Hilaire-Germain-Edgar, 112; Combing the Hair, 123; Princess Metternich, 123
- Delacroix, Ferdinand-Victor-Eugène, 111; Christ on the Cross, 112, 116; Ovid among the
- Scythians, 116 Delaroche, Paul, The Execution of Lady Jane Grey,
- 115 Detroy, Jean-François, Jason swearing Eternal
- Affection to Medea, 99
- Domenichino, 77; Landscape with Tobias and the
- Angel, 77, 81
- Dou, Gerrit, A Poulterer's Shop, 67 Duccio, 10; The Annunciation, 10, 11; The Virgin and Child with Saints, 12
- Dughet, Gaspard, 78; Ariccia, 88 Dürer, Albrecht, ascribed to, 27; The Painter's Father, 28, 40
- Dyck, Anthony Van, 59; Equestrian Portrait of Charles I, 59, 75; Lady Elizabeth Thimbelby and Dorothy, Viscountess Andover, 60; A Woman and a Child, 59, 74
- Eastlake, Sir Charles Lock, 6, 7, 9, 10, 28, 43, 111 Elsheimer, Adam, 77; Tobias and the Archangel Raphael, 81
- Eyck, Jan van, 27; The Arnolfini Marriage, 27, 32; A Man in a Turban, 27, 31; Portrait of a Young Man, 31
- Fabritius, Carel, Self-portrait, 65 Francia, Francesco, The Virgin and Child with Saints 22
- French School, 'The Wilton Diptych', 28, 29
- Gainsborough, Thomas, 59; The Morning Walk, 93, 106; Mr and Mrs Andrews, 93, 108; The Watering Place, 59, 93, 105 Gauguin, Paul, Flower-piece, 122
- Géricault, Jean-Louis-André-Théodore, A Horse Frightened by Lightning, 115 Giordano, Luca, 77; St Anthony of Padua, 83
- Giorgione, The Adoration of the Magi, 53; 'Il
- Tramonto', 53 Giovanni di Paolo, The Baptism of Christ, 13
- Gogh, Vincent van, 112; Sunflowers, 122
- Gossaert, Jan, 27; The Adoration of the Kings, 36; A Little Girl, 36
- Goya, Francisco de, 94; The Duke of Wellington, 94, 110; A Scene from 'The Forcibly Bewitched', 94, 110
- Goyen, Jan van, A View of Overschie, 66 Greco, El, 78; The Adoration of the Name of
- Jesus, 89; Christ driving the Traders from the Temple, 78, 90 Guardi, Francesco, A Caprice with Ruins on the
- Seashore, 98
- Guercino, 77; The Incredulity of St Thomas, 77, 82
- Hals, Frans, 60; Family Group in a Landscape, 62; Portrait of a Man, 60, 64
- Heyden, Jan van der, 60; An Architectural Fantasy, 69
- Hobbema, Meyndert, 59; The Avenue,
- Middelharnis, 60, 71 Hogarth, William, 93; The Countess's Morning Levée, 104; 'Marriage à la Modé, 93; The Shrimp Girl. 104
- Holbein, Hans, the Younger, 27; 'The Ambassadors', 28, 42; Christina of Denmark, Duchess of Milan, 28, 42
- Holwell Carr, Rev, 5, 9, 43, 59, 77, 78 Honthorst, Gerrit van, *Christ before the High Priest*,
- 61 Hoogh, Pieter de, The Courtyard of a House in Delft, 60, 68; An Interior Scene, 60
- Ingres, Jean-Auguste-Dominique, 111; Madame Moitessier Seated, 112, 117
- Jordaens, Jacob, 59; Govaert van Surpele and his Wife, 59, 76
- Klimt, Gustav, 7, 112; Portrait of Hermine Gallia, 112, 126
- Koninck, Philips, 60; Extensive Landscape with a Road by a Ruin, 60, 67

- Lancret, Nicolas, 93; The Four Ages of Man, 93; 'La Tasse de Chocolat', 94, 102
- Lane, Sir Hugh, 7, 111, 112
- Lawrence, Sir Thomas, 6, 94; Queen Charlotte, 94, 109
- Lenain, Louis, The Adoration of the Shepherds, 85 Leonardo da Vinci, 43; The Virgin and Child with St Anne and St John the Baptist, 44, 45; The Virgin of the Rocks, 43, 46
- Lippi, Filippino, The Adoration of the Kings, 26
- Lippi, Fra Filippo, The Annunciation, 16
- Lochner, Stephan, 28, St Matthew, St Catherine and St John the Evangelist, 38
- Longhi, Pietro, A Fortune-teller at Venice, 98 Lorenzo Monaco, 9; The Coronation of the Virgin, 9,12
- Lotto, Lorenzo, A Lady as Lucretia, 56
- Lucas van Leyden, A Man aged Thirty-eight, 37
- Mabuse-see Gossaert

Virginal, 60, 69

Aristaeus, 53

Landscape, 36

Peel, Sir Robert, 6, 9, 59

Jacques Cazotte, 94, 103

9, 20; The Nativity, 18

Raphael and St Michael, 9, 26

Pisanello, The Vision of St Eustace, 13

Pissarro, Camille, The Côte des Boeufs at

L'Hermitage, near Pontoise, 120–121

Martyrdom of St Sebastian, 9, 10, 17

the Father and the Holy Ghost, 95

with a Man killed by a Snake, 85

45; The Transfiguration, 43

Redon, Odilon, 7, 112

Moreau, Gustave, 7, 112

- Maes, Nicolaes, Sleeping Maid and her Servant, 68 Manet, Edouard, Music in the Tuileries Gardens, 111, 119; The Waitress, 112, 119
- Mantegna, Andrea, The Agony in the Garden, 21; Samson and Delilah, 18; The Virgin and Child with the Magdalen and St John the Baptist, 9, 18
- Masaccio, The Virgin and Child, 10, 14
- Masolino, ascribed to, St John the Baptist and St Jerome, 16 Master of Liesborn, 27; The Annunciation, 27, 38 Master of the St Bartholomew Altarpiece, St

Peter and St Dorothy, 28, 38 Memlinc, Hans, 27; The Virgin and Child with

Michelangelo, 43, 78; The Entombment, 43, 49

Monet, Claude-Oscar, The Beach at Trouville, 112, 120; The Water-lily Pond, 120

Moretto da Brescia, Portrait of a Young Man, 56

Murillo, Bartolomé Esteban, 78; Peasant Boy leaning

Moroni, Giovanni Battista, 'The Tailor', 56

on a Sill, 78; The Two Trinities, 78, 92

National Art-Collections Fund, 28, 44, 78

Nattier, Jean-Marc, Manon Balletti, 99 Niccolo dell'Abate, ascribed to, The Story of

Oost, Jacob van, A Boy aged Eleven, 76

Orcagna, Style of, Noli me Tangere, 12

Ostade, Adriaen van, An Alchemist, 68

Parmigianino, 43; The Madonna and Child with

Patenier, Joachim, ascribed to, St Jerome in a Rocky

Perugino, Pietro, 9; The Virgin and Child with St

Piero di Cosimo, A Mythological Subject, 10, 26

Pittoni, Giovanni Battista, The Nativity with God

Pollaiuolo, Antonio and Piero del, ascribed to, The

Pontormo, Joseph in Egypt, 52 Poussin, Nicolas, 77; The Adoration of the Shepherds, 86; A Bacchanalian Revel, 85; Landscape

Raphael, 7, 43; 'The Ansidei Madonna', 43, 47;

Rembrandt, 5, 7, 59, 60; Belshazzar's Feast, 60, 65; Hendrickje Stoffels, 60, 63; Self-portrait

Pope Julius II, 44, 45; St Catherine of Alexandria,

127

Piero della Francesca, The Baptism of Christ,

St John the Baptist and St Jerome, 43, 52; The

Palma Vecchio, Portrait of a Poet, 56

Mystic Marriage of St Catherine, 52

Perronneau, Jean-Baptiste, Portrait of

Metsu, Gabriel, A Man and Woman beside a

Saints and Donors, 33; A Young Man at Prayer, 35

- aged Sixty-three, 60, 64; Woman bathing in a Stream, 59, 64
- Reni, Guido, 9, 77; Lot and his Daughters leaving Sodom, 77, 82; Susanna and the Elders, 9
- Renoir, Pierre-Auguste, 111; The Umbrellas, 111, 121
- Reynolds, Sir Joshua, 59, 94; Anne, Countess of Albemarle, 94, 108; General Sir Banastre Tarleton, 94, 107; Lord Heathfield, 93
- Ribera, Jusepe de, 77; Jacob with the Flock of Laban, 92 Ricci, Sebastiano, Bacchus and Ariadne, 95
- Rigaud, Hyacinthe, 94; Portrait of Antoine Paris, 99 Rosa, Salvator, 78; Landscape with Tobias and the Angel, 83
- Rousseau, Henri, 7; Tropical Storm with Tiger, 112, 125

Rousseau, Théodore, 111

- Rubens, Peeter-Pauwel, 5, 7, 59; Autumn Landscape with a View of Het Steen, 59, 73; 'Le Chapeau de Paille', 60, 74; The Judgement of Paris, 73; 'Peace and War', 6, 59, 72
- Ruisdael, Jacob van, 59, 60; Landscape with Ruined Castle and Church, 60, 71

Ruskin, John, 9, 77

Saenredam, Pieter, Interior of the Grote Kerk, Haarlem, 60, 65

Salting, George, 7, 60, 111

- Sarto, Andrea del, Portrait of a Young Man, 48
- Sassetta, The Whim of the Young St Francis to become

- a Soldier. 13
- Sebastiano del Piombo, 43; The Raising of Lazarus, 43, 51

Seurat, Georges-Pierre, Bathers, Asnières, 112, 122 Signorelli, Luca, The Adoration of the Shepherds, 24 Sisley, Alfred, The Horse Trough at Marley, 120 Spranger, Bartholomeus, The Adoration of the Kings, 39

- Steen, Jan, 60; Music making on a Terrace, 68 Strozzi, Bernardo, Personification of Fame, 83 Stubbs, George, The Milbanke and Melbourne
- Families, 94, 104
- Taylor, Sir John, 6
- Thoré, Théophile, 60
- Tiepolo, Giovanni Battista, 93; An Allegory with Venus and Time, 93, 96; The Banquet of Cheopatra, 98
- Tiepolo, Giovanni Domenico, The Procession of the Trojan Horse into Troy, 98
- Tintoretto, Jacopo, 78; The Origin of the Milky Way, 57; St George and the Dragon, 43, 58
- Titian, 7, 9, 43, 44, 78; Bacchus and Ariadne, 6, 43, 44, 54; The Death of Actaeon, 44, 55; The Holy Family and a Shepherd, 43; 'Noli me Tangere', 55; Portrait of a Man, 55
- Toulouse-Lautrec, Henri de, Woman seated in a Garden, 123
- Tura, Cosimo, An Allegorical Figure, 19
- Turner, Joseph Mallord William, 6, 78, 111; Dido building Carthage, 111; The 'Fighting Téméraire', 111, 113; Rain, Steam and Speed, 111, 114

Uccello, Paolo, The Battle of San Romano, 9, 14-15

- Valentin, Le, The Four Ages of Man, 77, 82
- Velázquez, Diego, 44; Boar Hunt, 78; Kitchen Scene with Christ in the House of Martha and Mary, 77 Philip IV of Spain in brown and silver, 78, 91; 'The Rokeby Venus', 78, 89
- Velde, Willem van de, the Younger, 60 Vermeer, Johannes, 60; Young Woman seated at a
- Virginal, 60, 69; Young Woman standing at a Virginal, 60, 70 Vernet, Claude-Joseph, A Sea-shore, 103
- Vernon, Gift, 6, 111
- Veronese, Paolo, 43; The Family of Darius before Alexander, 43, 58; The Vision of St Helena, 58
- Verrochio, Andrea, Follower of, 9; Tobias and the Angel, 24

Vouet, Simon, Ceres and Harvesting Cupids, 84 Vuillard, Edouard, The Chimneypiece, 126

Watteau, Jean-Antoine, 93; 'La Gamme d'Amour', 93, 100

- Weyden, Rogier van der Pietà, 34; St Ivo, 34 Wilkins, William, 5-6
- Wilson, Richard, 93; Holt Bridge on the River Dee,

'Wilton Diptych' see French School Wynn Ellis, 6, 60

Zoffany, Johann, Mrs Oswald, 109 Zurbarán, Francisco de, St Margaret, 92

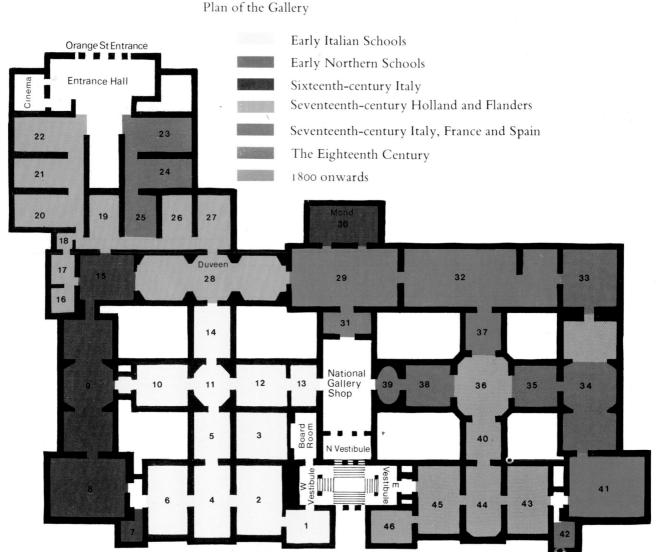

Main Entrance